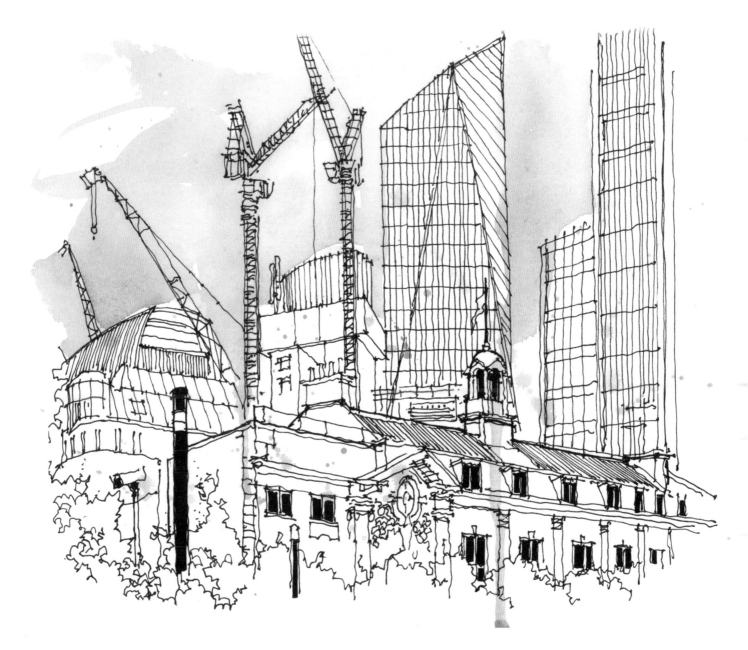

Sketch Club

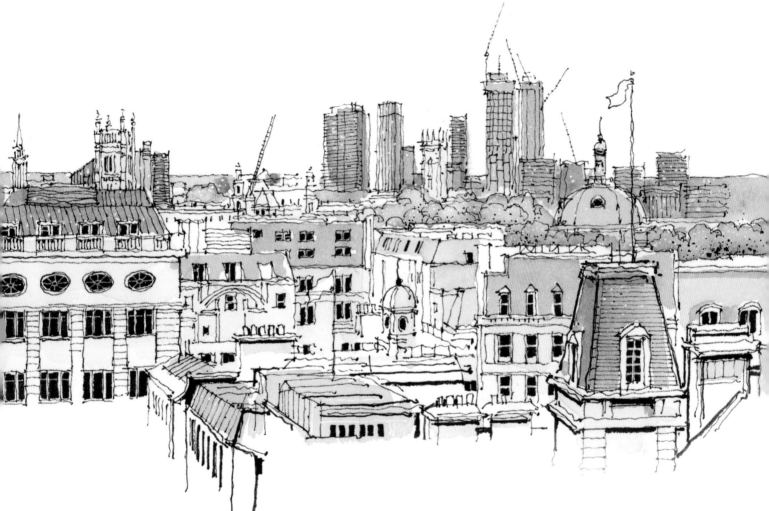

Urban Watercolour

Phil Dean

ilex

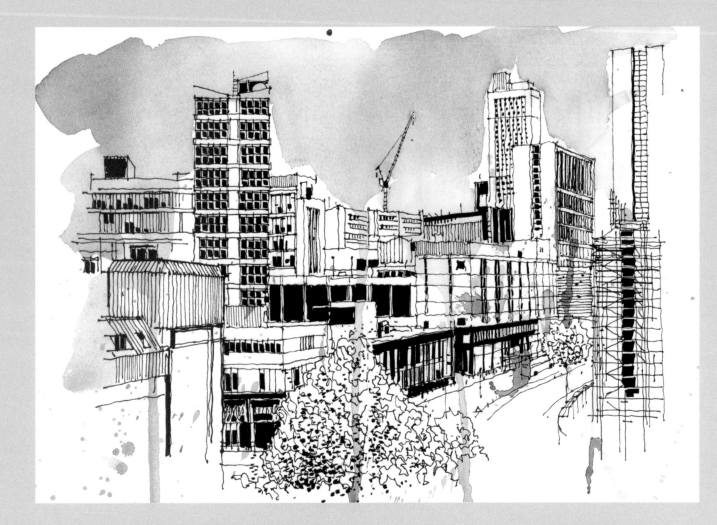

An Hachette UK Company
www.hachette.co.uk

First published in the United Kingdom in
2022 by ILEX, an imprint of Octopus
Publishing Group Ltd
Octopus Publishing Group
Carmelite House
50 Victoria Embankment
London, EC4Y 0DZ
www.octopusbooks.co.uk
www.octopusbooksusa.com

Design and layout copyright
© Octopus Publishing Group 2022
Text and illustrations copyright
© Phil Dean 2022

Distributed in the US by
Hachette Book Group,
1290 Avenue of the Americas,
4th and 5th Floors, New York, NY 10104

Distributed in Canada by
Canadian Manda Group,
664 Annette St., Toronto, Ontario,
Canada M6S 2C8

Publisher: Alison Starling
Commissioning Editor: Ellie Corbett
Managing Editor: Rachel Silverlight
Editorial Assistant: Jeannie Stanley
Art Director: Ben Gardiner
Design: JC Lanaway
Production Controller: Serena Savini

ISBN 978-1-78157-862-9

A CIP catalogue record for this book
is available from the British Library

Printed and bound in China

10 9 8 7 6 5 4 3 2 1

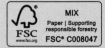

FSC
www.fsc.org
MIX
Paper | Supporting
responsible forestry
FSC® C008047

Contents

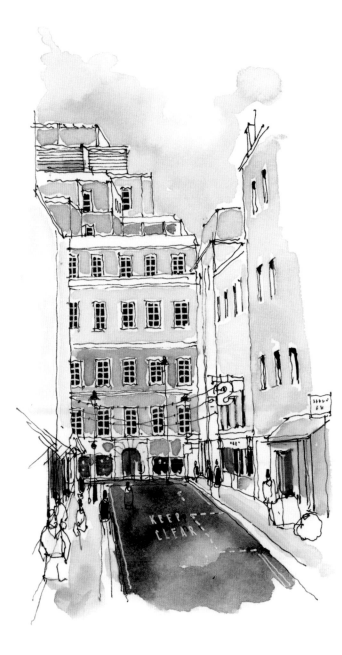

Introduction

Watercolour painting is often seen as a very traditional medium, for bucolic, beautiful views fit for an art gallery, or, at the other end of the scale, a chocolate box. Watercolour techniques can seem highly technical, hard to understand and inaccessible. It looks to the beginner like a club that you can't get into — the artistic bouncers eye you up and after careful consideration say, no, I'm afraid you're not coming in.

- -

That's exactly how I felt about watercolour for many years. I didn't connect with it as a medium and so I largely overlooked it in favour of more 'accessible' media. I did learn the basics of water-based paint when I studied as a young graphic design student, but many of the techniques didn't stick because I saw watercolour painting as the past and new media, such as markers, as the future.

So when I was asked to write this book I have to admit I was challenged. Urban... *watercolour*?

For me personally, the very idea of urban drawing was the antithesis of watercolour. As an urban artist, my work is fast, edgy, challenging, grungy and representative of the urban environment. I had no conception of how watercolour, the old-school, genteel medium, could represent faithfully this approach and the subject matter I loved so much.

But I couldn't have been more wrong. As I explored the techniques watercolourists used in their work, I found that these techniques really worked for me as an urban artist. I knew the basics with pen, brush, water and paint thanks to my art school education, so I set out to create a book aimed at people who want to explore the medium of watercolour without being encumbered with technical baggage or an art education. I found that watercolour was, in actual fact, one of the most accessible and spontaneous media that required only a bit of planning and a small amount of bravery.

This book is for you, the sketcher or beginner artist, who likes the idea of splashing a bit of colour around on your drawings without the pretension of high-brow art. Watercolour can be so easy to use and this book will show you how to prepare some basic equipment and materials that will get you great results.

If you've read my previous book, you'll know how much I love to get out and about sketching in the city, and this book is an extension of that, with encouragement to get out and create great paintings on location. Throughout the book are 15 step-by-step exercises that will take you on a journey from the very basics of watercolour through to more advanced painting techniques.

I don't pretend that this book is the most exhaustive book ever written on watercolour. There are lots of overly tricky techniques that I've left out because I want to encourage you to experiment with watercolour and not be intimidated by the medium. There are also plenty of more complex fine art watercolour books out there if you want a more elaborate exploration of the medium. But I've been excited to see people in my classes using watercolour in urban drawing on an everyday basis and my aim with this book is to open the door for everyone to dip their toe in the water and try the medium out.

I have unexpectedly fallen in love with watercolour during the writing of this book. I had thought the fiddling around with water, brushes and paint would be a barrier to creating, but it simply isn't. I've discovered the ease of paint application, the happy accidents, the energy of painting and the ability to mix thousands of colours from a small palette. My hope is that this book opens an artistic door for you to come on this journey towards loving watercolour with me.

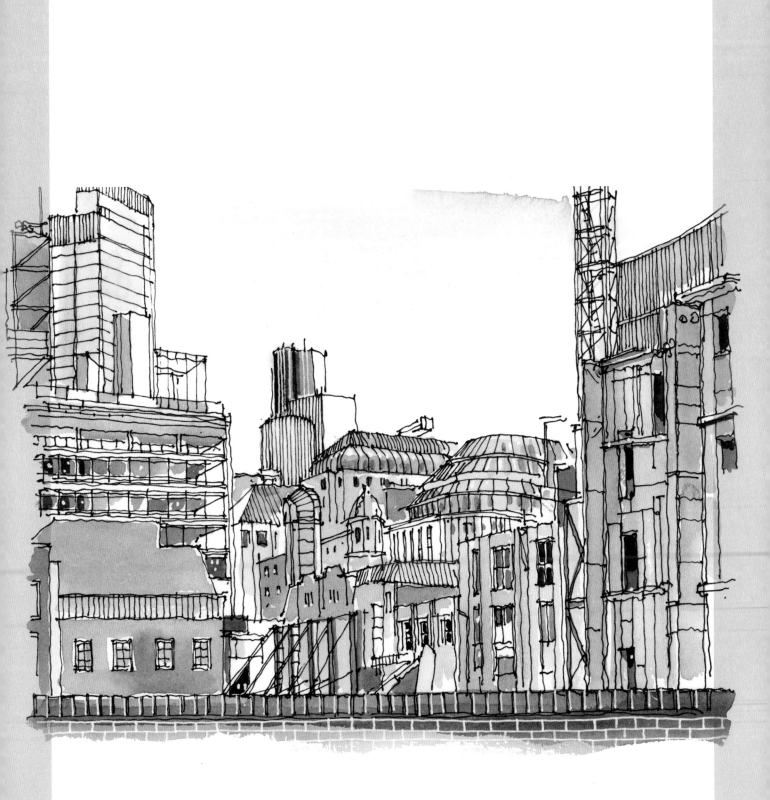

Equipment and materials

You don't need to spend a lot of money to get started painting with watercolour. All you need is paper, paint, a brush, pen or pencil and, of course, water. However, there is a bewildering array of watercolour products out there and in this section of the book, I'll try to help you choose what is right for you, and get rid of any barriers to putting brush to paper.

- -

My first piece of advice would be to keep it simple with your watercolour equipment and materials. Then, as you progress, you can invest further. If you are a beginner and finding your feet with the medium, try experimenting with one or two low-cost options – there are plenty out there. Then, if you find you're enjoying watercolour, it will give you the confidence to experiment further with different brushes, pens, paper or paints.

Experienced watercolour artists have an extensive range of tried-and-tested materials that they know perform well for them. I have participated in workshops where this wealth of knowledge can be intimidating to the beginner, but we all have to start somewhere. I have found that a compact watercolour set combined with humble materials will do a perfectly good job in most urban watercolour situations.

I also find recommendations from other artists to be a great way of working out what equipment and materials may work for you. If you're a member of a sketching group or online artist community, don't be afraid to ask for tips on what works for artists whose work you admire. You'll often be surprised to find out they keep it simple too.

Waterproof ink

Before you dive into gathering your watercolour materials, it is useful first to work out what kind of pen you will use for your linework. The first thing to ensure is that the ink you are using is one hundred percent water*proof*. It may sound blindingly obvious, but the last thing you need is to be sketching a scene for an hour with a non-waterproof pen and then when you add colour, it bleeds everywhere. (When used intentionally, of course, this can be used to great effect – see the illustration on page 65).

A lot of pens *say* they are waterproof, but in fact they are not. Before you head out into the urban landscape, it's always worth testing your equipment to make sure it will give you the results you desire. Is the pen making the right mark on the watercolour paper? Is the ink waterproof? A safety-first approach will ensure no costly mistakes are made and give you confidence when you're live sketching.

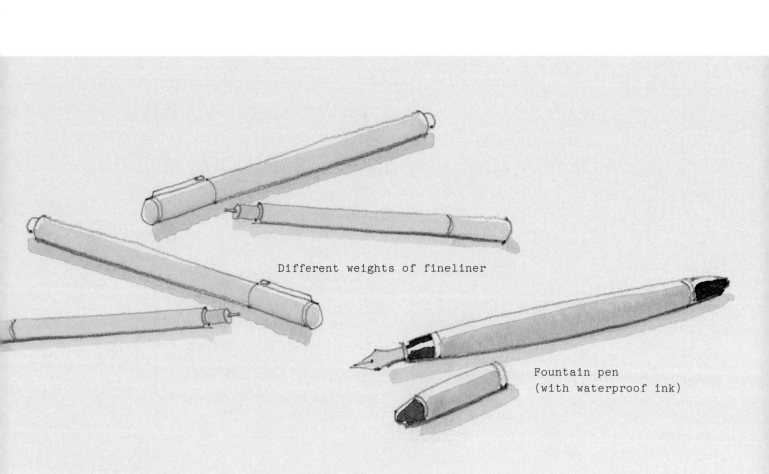

Different weights of fineliner

Fountain pen
(with waterproof ink)

PENS AND INK TYPES

Fineliner

Pigment fineliners are the go-to pen for the budding urban watercolour artist. They are easy to use, dry very quickly and give consistent results every time.

As a rule, pigment fineliners are the safe bet for use with watercolour and will stand firm against heavy water usage, but even with these pens, it's prudent to wait until the ink is properly dry before adding the watercolour. There is a wide range of pens available at a range of price points and my advice would be to buy three or four individual pens and try them out. My nib of choice for watercolour sketching would be a 0.2mm or 0.3mm as I prefer a finer line, but remember it's your sketch and if you prefer a thicker line, go for it.

Brands to consider: Faber-Castell Ecco Pigment, Sakura Micron Pigma, Staedtler Pigment, Shoreditch Sketcher

Fountain pen

Some sketchers use fountain pens to very good effect and the use of a steel pen nib can deliver a range of line weights and strokes that can be very satisfying. A fine nib can deliver very interesting line effects on a toothy (or heavily textured) watercolour paper. The same rules regarding ink apply to fountain pens: always use waterproof ink as most ink supplied with pens isn't water fast. I have found that carbon ink is the best for watercolour use, but bear in mind fountain pen ink takes a little longer to dry than pigment liner ink, so make sure you hold off applying colour until completely dry.

Brands to consider: Platinum, Lamy, Sailor

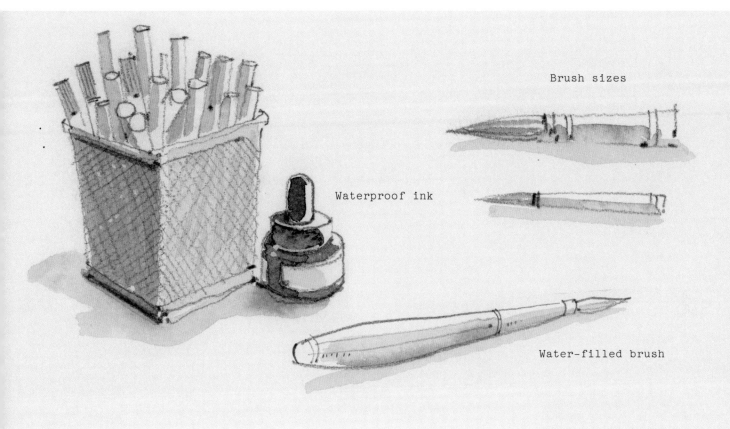

Brush sizes

Waterproof ink

Water-filled brush

Dip pen and ink

Dip pens are pens that you physically dip into ink: there is no ink stored in them and they therefore need dipping in ink every few strokes. It may sound like a major inconvenience in comparison to the ease of modern pens, but this medium can deliver interesting, varied results and be a lot of fun.

Dip pens can also be used with pigment inks that can't be used in some fountain pens. Remember the ink stays wet a lot longer, so smudging is a risk, and you really must wait until it dries before moving on to paint. Using a dip pen is more challenging than a pigment liner or pencil so I'd recommend that you give these pens a try after you have gained confidence with watercolour sketching.

Brands to consider: Winsor & Newton, Nikko, Tachikawa

- -

TIP
Always start at the top of the drawing and work down to avoid smudging your work. This applies to most sketching but is of particular relevance when you are working with ink.

Pencil types suitable for watercolour

Pencil is very watercolour friendly and pretty much every kind of lead pencil is suitable for watercolour use. There are no worries about bleeding and the carbon in the pencil doesn't interact with the water and sits beautifully beneath the paint. Pencil lines can also be very forgiving and the line weights can be varied, from soft to hard and fine to bold. When the watercolour has dried, pencil can also be worked on top of the paint.

Pencils are graded from 9H (hard) to 9B (black). For the beginner I would recommend getting a set of good-quality artist pencils from HB to 9B (don't bother with the H range of pencils as they are too hard for watercolour paper). It is much easier to correct soft pencil lines using a putty rubber, while hard lines are difficult to erase.

I always opt for a pencil between HB and 4B when sketching with watercolour, depending on the desired line and subject matter. For more detailed scenes, use a harder pencil; for looser, fluid subject matter, go softer. Always keep the lead sharpened in the pencil using a brass pencil sharpener, scalpel or sandpaper to ensure your lines are crisp and delicate. Clutch pencils are excellent for live sketching too: the lead is retractable and protected from damage, and some even come with a built-in sharpener.

Brands to consider: Koh-I-Noor, Derwent Graphic, Staedtler Lumograph, Winsor & Newton

Brushes

Watercolour brushes come in a bewildering array of sets and ranges, from basic student sets to eye-wateringly expensive professional ranges. This can feel like a minefield for experienced artists, let alone beginners.

Essentially, there are two types of brushes: synthetic brushes and natural brushes made from animal hair. The difference between the two ranges will barely be discernible for the beginner or intermediate artist in terms of your

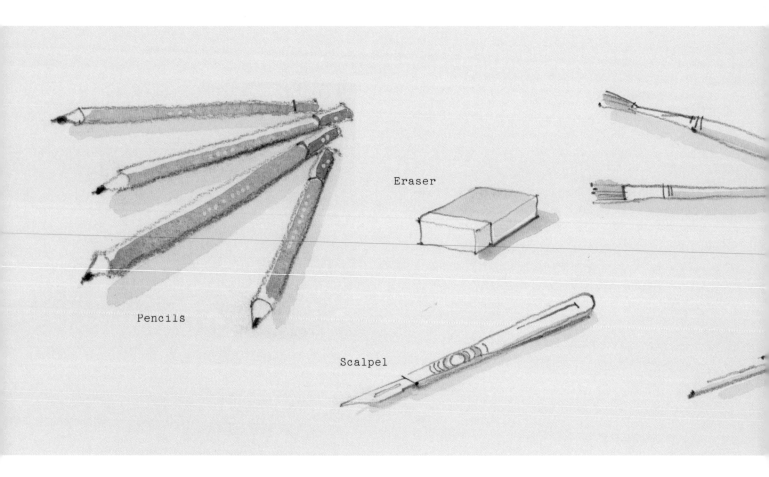

Eraser

Pencils

Scalpel

finished artwork, but the price difference is significant for obvious reasons.

My advice is that while you are finding your way with the medium of watercolour, begin by purchasing a basic set of brushes and a basic watercolour set. There really is no need to overspend at this stage. If you find you are really enjoying watercolour, then you might want to upgrade to more expensive brushes at some point. In my opinion, you only really need two brushes – a 4 Round and 10 Round covers most urban sketching eventualities (the 'round' refers to the shape of the brush), but it can be good to have a few options which a starter set will provide.

Portable watercolour sets

Portable watercolour sets are a brilliant way to try out watercolour in an urban environment. Everything is included in a compact set – paint, mixing palette, sponge and even the water is included in the barrel of the brush. They are the ultimate artist convenience, with everything you need in one place. I recommend starting here if you've never used watercolour before as the convenience of the set will tear down any barrier you might have to the medium.

The set I use has a wide range of bright colours and the brush is more than adequate for what I need. Just fill up the pen reservoir with water, and you're good to go!

There can be a lot of snobbery around watercolour materials, but I love the way these sets make watercolour accessible to the beginner and enjoyable to use. My advice is to make a portable set your starting point.

Brands to consider: Shoreditch Sketcher, Cass Art

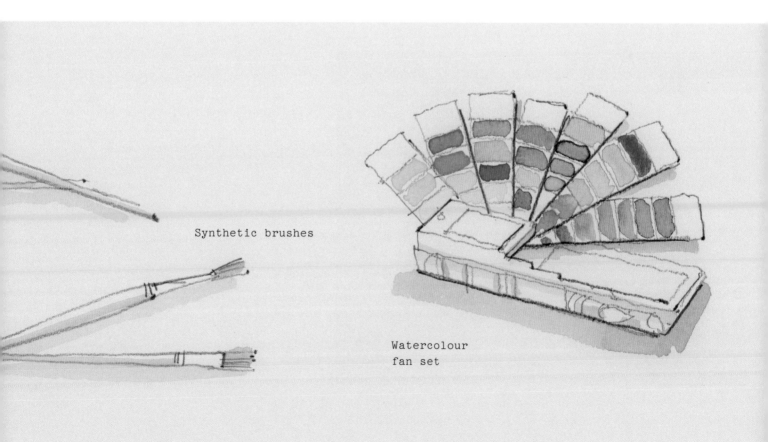

Synthetic brushes

Watercolour fan set

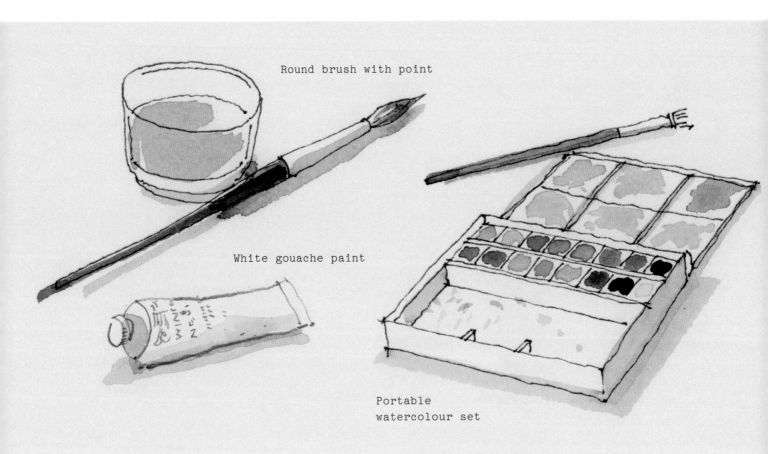

Round brush with point

White gouache paint

Portable
watercolour set

Paints

If you're not using an all-in-one watercolour set, you'll need to buy the components of your kit separately. Remember, the aim of the urban watercolour sketcher is to travel light, and I always have that in mind when purchasing equipment.

Watercolour paints come in pans – little blocks of watercolour paint that you add water to – and tubes which contain liquid paint that needs water adding to it. As a rule of thumb, the tubes are at the top end of the price range and the pans are more accessible at mid to low end.

When buying a set of watercolour paints, it is worth starting with a smaller set which will still provide enough colours to mix any hue that you will need. One of the advantages of watercolour over markers is that you have

every single colour you need in your palette, all you have to do is mix them.

The loose pans of paint can be a bit fiddly when you're out and about, so I prefer the pans set into a tin or set for ease of use. It is all about personal preference, and you'll work out which you prefer over time. My advice is to always go for the easy option, because there is already enough to think about when painting in an urban environment. The last thing you need is fiddly paints!

Brands to consider: Winsor & Newton, Cotman, Derwent, Cass Art, Kremer

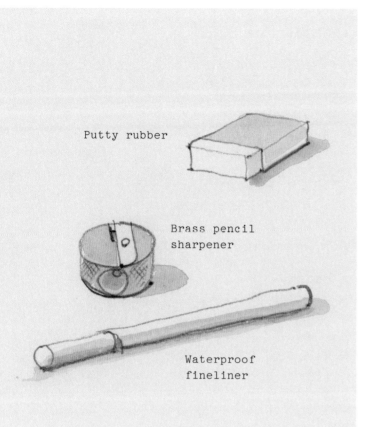

Putty rubber

Brass pencil
sharpener

Waterproof
fineliner

Along with your watercolour painting essentials, I always carry the following in my bag when I'm out and about and intending to work with watercolour:

- Small, dry sponge for mopping up excess water on overloaded paper and to 'lift off' excess colour. These sponges are easily available from art suppliers or you can just buy a cheap, small sponge from a housewares store.

- Small, sealed water bottle filled with tap water.

- Two or three loose A5 sheets of watercolour paper to try colours out before you commit to them on the page, and ideally similar to the paper you are using in order to get an accurate feel for the colours.

- Paper towel or tissues in a small resealable bag (like the ones you have to put your toiletries in at the airport) as watercolour can be messy and spillages do often happen!

- Bulldog clips, essential for keeping the pages of your sketchbook or paper secure in windy weather.

- Putty rubber or plastic eraser.

- Swiss Army knife, retractable craft knife or brass pencil sharpener – it's safety first on sharpening tools, so ensure that you're carrying a safe pencil sharpening kit (do remember if you are flying with your kit to put these items in your checked case or they will get confiscated, as I have learned the hard way).

- Sandpaper sharpening block – very useful to keep a point on the end of your pencils without sharpening down your pencils too often.

- Fold-up tripod stool – you need to be comfortable for watercolour sketching and if there's no seating to be found, a portable stool allows you complete control of your view of the location. This is non-essential, but it definitely makes life easier.

Bag

I see people with watercolour equipment in carrier bags or canvas shoppers, which is fine of course, but it stresses me out! I like to have a bag that is fit for purpose and can comfortably carry my kit in an easily accessible fashion. Lots of pockets for the various tools and equipment is essential, and invariably I use a backpack as it leaves my hands free for quick sketching as and when.

There are lots of purpose-made bags out there if you want to accommodate an easel or fold-up chair, but there is no real need to splurge on one of these if you already have a bag that is practically workable. However, waterproof pockets or sections can help keep your materials dry if your water leaks or if it rains.

Alternative materials and methods

Once you've got to grips with the basics of traditional watercolour paint, there are other water-based media you can add to build on and embellish your work.

- -

Watercolour markers

Although markers are easy and convenient, the limited colour palette means that you can't blend and mix as you would with watercolour paint. However, the paint in the markers is highly soluble with water and enjoyable to use, delivering bold colours that soften easily.

It can be fun to mix the marker-style application of the colour on the paper with water using a brush. It delivers a combination of styles – the crispness of the marker and the softness of the watercolour finish – which works particularly well with architecture.

Brands to consider: Winsor & Newton, Faber-Castell, Tombow

Watercolour pencils

Soluble watercolour pencils allow the sketcher to experiment with a pencil line finish but with the ability to add colour. It's always useful to have a few of these in your bag to add another layer of colour or lines. Watercolour pencils lend themselves to a loose wash approach that makes the lines 'bleed' in a satisfying way.

Try drawing the linework of your drawing in one or a few different colours using watercolour pencils. Perhaps use the colour of the subject matter to dictate which colours you use and then add water for tone and shading.

Brands to consider: Winsor & Newton, Faber-Castell, Derwent, Cass Art

Watercolour brush pens

Watercolour brush pens do take some getting used to, but the same watercolour principle applies, adding water to dilute the ink and sketching as you go. The nibs mimic a brush and give you a thin, delicate line and broad brush. These are good to use if you don't plan to sketch any linework, and it's always useful to keep a couple on hand, particularly black for shadows.

Try adding water with a watercolour brush to the brush marker sketch, too, to soften the colours and add further depth of tone. You can make the edges bleed, but if you are careful with water application, you can retain the integrity of the lines.

Brands to consider: Arteza, Winsor & Newton, Tombow

Watercolour pencils

Chunky clutch pencil

Watercolour
pencils

Watercolour brush pen

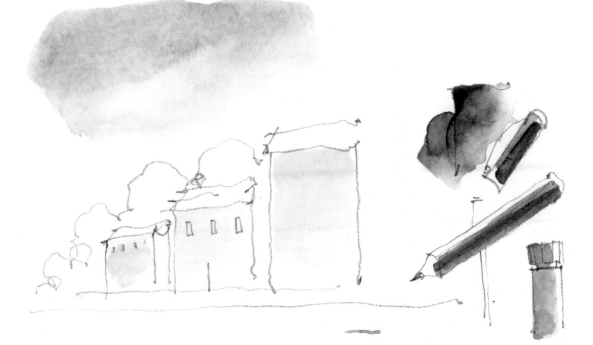

Watercolour marker

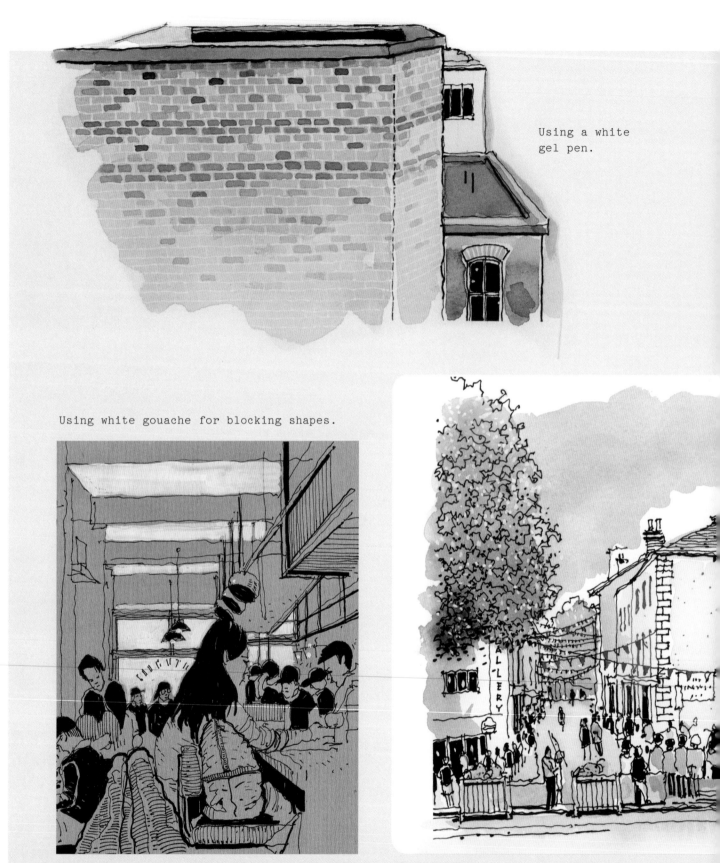

Using a white
gel pen.

Using white gouache for blocking shapes.

Using white gouache for highlights.

TIP
Just buy a tube of white
gouache in the first instance
— I always add white gouache
when I'm back in my studio and
use photographic references to
add details and highlights.

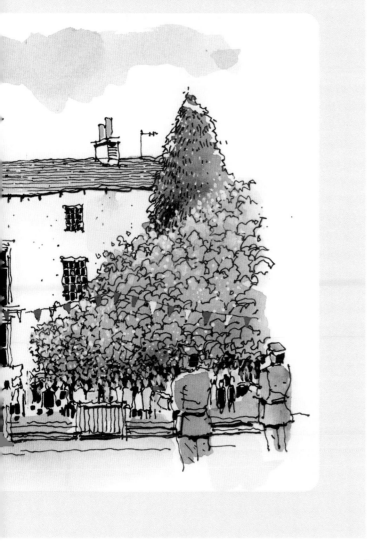

Gel pens

Gel pens are usually seen in the hands of children for colouring-in purposes, but they are a very grown-up tool in the hands of an artist. They come in a multitude of colours, although I find the white gel pens the most useful.

It's always worth having two or three white gel pens with various nib sizes in your bag to add little pops of white on top of the watercolour, but do this only when it's completely dry. Gel pens are lovely for adding mortar on brickwork, roof tiles or light in windows. Although perhaps not a tool for the purist, I use anything and everything in watercolours to achieve the effect I'm looking for.

For the urban watercolourist, having a couple of gel pens means you don't have to mix gouache for highlights, with the added bonus that they come in lots of colours and sit opaque on top of waterproof black ink.

Brands to consider: Sakura Gelly Roll, Uni Posca, Pentel

Gouache

Designer's gouache is an opaque water-based paint available in tubes and pans and can be used in a similar way to watercolour.

Gouache is also perfect for working on top of a piece where you want an opaque finish to the paint. Gouache is particularly good for windows, lights and any highlights you want to add after the sketch, sitting above the top layer of the painting. Ensure your watercolour is completely dry before you add gouache, otherwise the gouache will just be another watercolour and blend into it.

It's also worth knowing that you can get a completely flat, opaque colour with gouache, which is ideal for flat skies or roads. However, this may be a bit tricky to achieve in an urban environment and might be fun to experiment with back at your desk.

Brands to consider: Winsor & Newton, Caran d'Ache, Daler-Rowney

Watercolour book

For urban watercolour work, I prefer to use an actual *book* when
I'm out and about — it's practical and I love the idea of all
my drawings and paintings collected together in one place, like
an artist's journal.

-- --

In this section, we'll explore the key things to consider when selecting a watercolour art book. It can be very rewarding to experiment with different kinds of books and, over time, you will work out what kind of book you prefer.

When out and about in an urban environment, the main principles are portability, ease of use and suitability for the medium. Watercolour sketchbooks and watercolour paper in general are more expensive than regular sketchbooks due to the more complex paper manufacturing process, but this need not put off the budding urban watercolourist as there is still a wide range of affordable papers.

You will also discover that watercolour paper comes in sealed 'blocks' of paper and you need a palette knife or penknife to extricate the sheet from its glued block. Personally, I would avoid these as an urban artist – not worth the effort when a bound book is so much easier.

Size matters
Small is beautiful! A smaller A5-sized sketchbook can be the perfect size for on-the-move sketching. It is portable, unobtrusive and the canvas of the double-page spread is large enough to capture the bigger scenes and still perfect for the more intimate sketches. Most brands have books around this size, so this is where I would start.

If you like to get settled in a location and have more time on your hands, then it's always useful to keep an A4 sketchbook on hand in case you're in an expansive mood. There are also larger-format watercolour books available and when you get more confidence and want to tackle larger scenes, then an A3 book would be perfect, which would allow you lots of lovely white space on the page to compose your scene.

Pen to paper
The texture of watercolour paper varies greatly across watercolour sketchbooks, from a super-smooth finish to heavily textured, and there is no right or wrong, it just depends how you're feeling and what you want your finished sketch to look like. Experimentation is key and the only way to decide is to pop into your local art supplies shop and physically touch the paper. If you're looking for a flat, clean colour application, go smooth; if you're looking for craggy character, go for a 'toothier' or rough finish.

Watercolour paper comes in a limited variety of weights as they tend to need to be on the heavy side to cope with the amount of water applied. As a rule, the heavier your paper, the more water you can apply – 300gsm (grams per square metre) is a good heavy-weighted paper and will cope with anything you throw at it, while 200gsm will generally be equally up to the job and slightly cheaper too.

I would start with a chunky texture for the sheer fun of it and see if you like the textural effect the paper gives to your colour. Good-quality paper is essential in watercolour, but entry-level own-brand watercolour paper will be more than adequate for what you need when starting out.

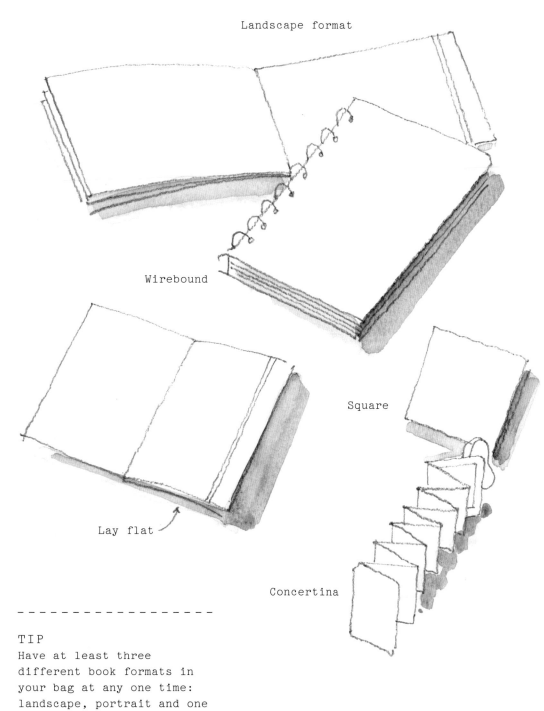

Landscape format

Wirebound

Square

Lay flat

Concertina

- - - - - - - - - - - - - - - - - - -

TIP
Have at least three
different book formats in
your bag at any one time:
landscape, portrait and one
other 'interesting' format.

Binding decision

My preference is for a watercolour sketchbook that lays 'flat' so the sketcher can make the most of the full double-page-spread format available. When you look at sketchbooks in store (which is essential), try and lay them flat. If they don't lay flat, there will be an ugly gutter in the middle of your sketch, and you will find the book difficult to use.

Wire or spiral-bound books are popular for this reason, but I prefer 'section sewn' books, where the binding lays completely flat due to the sections of paper physically sewn together. Spiral and wire-bound books have punch holes down the edge, which spoils the aesthetic of the art for me.

You can even find unusual watercolour book formats, such as handmade paper with deckled or unfinished edges, and concertina sketchbooks, all of which are worth trying because alternative formats inspire the artist to try something different.

The shape of it

You will discover that the landscape format rules in the world of watercolours. This is a legacy format from when watercolours were primarily bucolic landscapes, so much so that the subject matter became the name for the format.

It must be said that widescreen landscape-format sketchbooks are just as effective at delivering breathtaking cityscapes as they are rural landscapes. The square format delivers an Instagram-friendly canvas that dictates a different approach where image cropping is essential. Portrait-format books allow the sketcher to capture more of the scene on a taller canvas, which is great for buildings.

The landscape format is a good place to start, especially if you haven't tried it before, but it isn't obligatory, and if you prefer a portrait format then do seek out that format from the start. Also, the landscape book turned on its edge in a vertical situation becomes a very exciting crop for a section of a scene.

There's more to life than white

White is not the only paper colour for watercolours. Coloured sketchbooks are an interesting option too and can add a seductive dimension to your sketches. Tinted smooth-finish paper and pale background colours are perfect for urban sketching, and adding white highlights is a satisfying way to add instant depth to the linework. Try textured paper too, which can add another dimension to pencil and charcoal sketches.

Watercolour book rule #1 – there are no rules

It's good to begin by establishing what your watercolour book 'rules' are, even if you decide there are none.

If you decide that every single mistake is staying in the book, that gives you permission to just crack on regardless. In my experience, it is good to have the freedom to paint what you like and make mistakes, happy or otherwise.

This may sound odd, but if you allow yourself to make mistakes and move on to the next page, it can be very liberating. Some artists use their book as a pristine collection of artworks and others use it to jot and sketch everything they see. I'm in the latter camp and I prefer to see my sketchbook as a visual journal. It's very satisfying to look back on the aborted artwork among the more successful outcomes – it's all part of the watercolour journey, and there's no such thing as a bad painting in my book.

This principle applies even more so in urban watercolours. I guarantee you will make mistakes, applying too much paint that you can't remove, splashing water on your drawing and smudging your linework (I do it all the time). But watercolour can be very forgiving, and one person's splodge is another's focal point. The key thing to remember is to embrace the 'accidents', go easy on yourself, and think of your sketchbook as a story in itself.

As an urban watercolour sketcher, try to carry your book and a basic watercolour set with you whenever possible. It helps if you have a ready-made, portable mini kit that you can have with you for all occasions. I can't stress this enough as it's the only way to ensure you are constantly sketching and splashing on the watercolour, and you will find this creates a spontaneity that will improve your work no end.

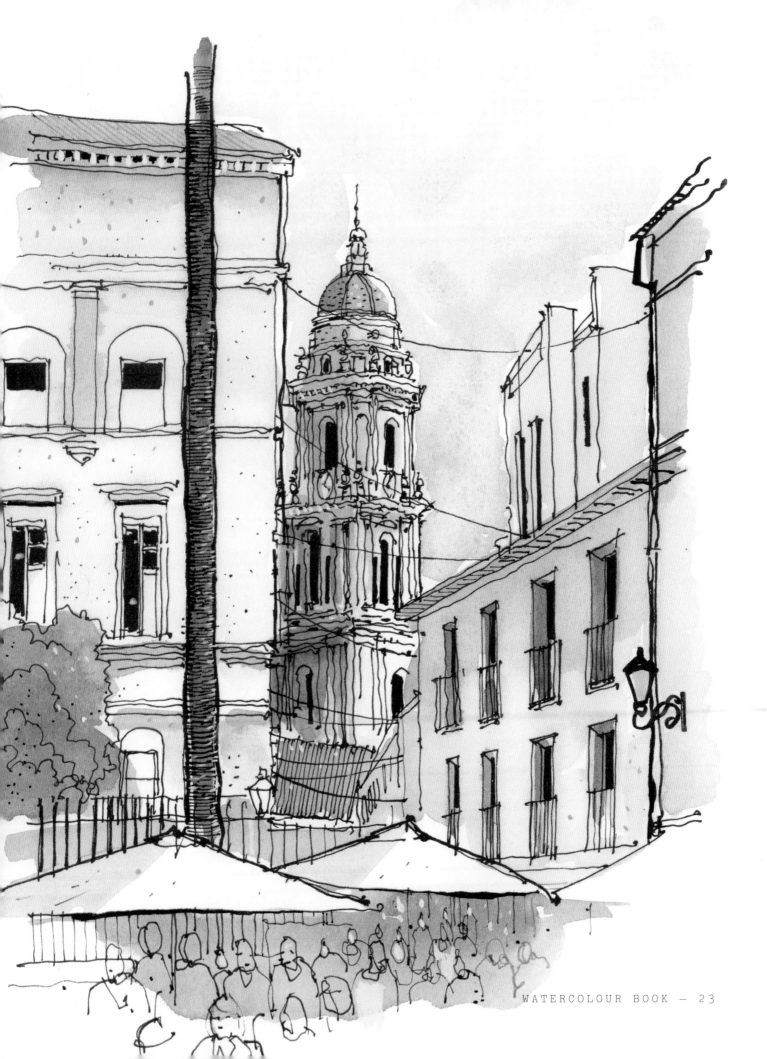

Up and running

Now you have everything you need to get going, here are a few dos and don'ts that will make your first forays into urban watercolour more enjoyable.

- -

DO: Get excited

Nobody ever set out to paint something that is dull or boring, so make sure that your subject matter interests you and, more importantly, challenges you. Whether it's a rooftop view of a vibrant city or an intimate snapshot of a neighbourhood, make sure that the subject matter tells a story or helps the viewer see the city in a different way. A painting is not a photograph so use your imagination to bring a new perspective to the view you are capturing.

DO: Sit comfortably

It's virtually impossible to stand when painting with watercolours, so I always try to find a quiet spot away from the crowds where you can sit down to get set up. There may be seating available, such as benches, in a perfect location, but this doesn't always happen. This is where your portable chair comes in and allows you to pick out the perfect spot with no compromise.

DO: Work fast

Work quickly to capture the energy and vitality in a scene. This will help you keep the scene together and not get lost in the process. How fast you work will be down to how experienced you are but, in my experience, two hours is a good time frame to create a really interesting piece of work. And if you think you've finished a piece, move on to a clean sheet and go again with a different angle of the same scene.

DO: Make mistakes

I've already talked about how important mistakes are, and I make no apologies for reinforcing it here. Embrace the wonky lines, the blobby watercolour, the awkward angles and the botched colour. Watercolour is very forgiving so you should persevere because nobody else will see the 'mistakes' but you, and no urban watercolour is entirely accurate. The aim is to create something that is true to you and to the scene you're painting.

DON'T: Be scared

At a recent workshop, a participant was intimidated by the complexity of the architecture, the light and her perceived inability to make a good job of it. It's always worth remembering that what you are doing is for you, and it is always good to be artistically challenged. I love that thrilling feeling of a challenging empty sheet of paper and how I'm going to make line and wash bring it to life. Embrace it.

DON'T: Stop

I've lost count of the number of times I've realized that, some way into an artwork, I've made perspective mistakes that are just getting worse, or the composition has all gone wrong, or my scale is all out. It seems to be going downhill fast. My advice is always to keep going. No one will notice and it doesn't matter. The instinct is to turn the page and start again, but resist and persevere and you will be rewarded. The more you work on it, the less you will notice the so-called errors.

DON'T: Be precious

Watercolour can be a purist school with rules and regulations around what you should and shouldn't do. Watercolour artists are continuing a fine tradition that has been going for hundreds of years, but don't let that hold you back. Mix media. Watercolour with marker or gel pen? Gouache with watercolour pencil? Why not? Have fun by mixing old and new media and be adventurous. I think of it as a meditation on the architecture I'm painting – a fantastic mixture of classical and contemporary.

DON'T: Forget to have fun

Sometimes, when you have all the watercolour paraphernalia around you and you're trying to capture a tricky scene in difficult conditions, it is hard to remember you're doing this for recreational reasons. Adding watercolour paint to a line drawing is one of the purest forms of artistic pleasure and is an absolute joy. Instant gratification with a paintbrush and fun in its truest sense.

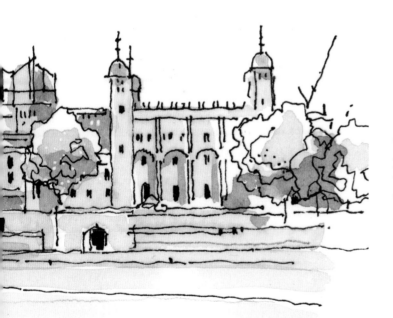

Urban drawing 101

At the heart of every good watercolour is good drawing, so I thought it would be useful, before we begin introducing paint, to go over the basic principles I use with my urban drawing. I firmly believe that if you use the following simple drawing techniques, you will elevate your sketches and be on the way to creating work you can be proud of. In this chapter, I wanted to introduce and expand on some basic techniques that will increase your enjoyment and satisfaction of the drawing and watercolour process.

I have kept this chapter as a high-level overview of urban sketching in the context of watercolour. If you want to dive deeper into the techniques in this section, I recommend you obtain a copy of my first book, *Urban Drawing*, which delves into each subject in greater detail.

This is also the moment to clear up the misconception that not everyone can draw. Believe it or not, we can all draw and the more we do it, the better we get. The easy techniques in this section will give you the tools to improve your drawing, and get the best out of yourself and your practice. Let's get drawing!

Perspective

If there's one thing that unites urban artists, it's the universal apprehension around perspective. And I get it — angles flying everywhere, curves, domes, cylindrical objects… the urban environment has it all. But I genuinely think there is nothing to fear for the beginner and my simple approach will let you off the hook and free you up to enjoy your drawing experience.

Starting angle

- -

Much has been written on the principles of perspective and if you want to know more about this geometric technical world, there are plenty of books that will help you to study the science of it further. But I'd like to encourage you to join me in the worry-free world of perspective, where inaccuracy is welcomed and even encouraged. The key is to treat perspective with respect but not let it rule your drawings.

My simple technique to bringing perspective into my drawings is to align my pen to the angle I'm looking at in my scene, whether it's a leaning crane, the angle made by two buildings or a road leading into the distance, and then transfer that as a line on the page. This easy trick has got me out of many perspective scrapes where I wanted to get a more accurate angle or an anchor line to build other angles off it. The key, as always, with drawing is to continually look at the subject matter – your focus should be on the scene in front of you and not on the page under your pen.

Another helpful perspective trick that comes in very useful when urban drawing is finding your eye line (which is the horizon line) and then looking at how the perspective lines come off it. To find your eye line, just look straight ahead and see how the angles spread away from the central point that you are looking at.

My style of drawing is not to map out the scene first, using pencil lines to find the perspective angles, but to jump straight into a scene and build out from a key angle that will help set the perspective for the entire drawing. This can seem quite daunting for the beginner initially, but I find that, once that first hurdle is overcome, this method can instil a confidence with perspective, and the knowledge that all kinds of perspective challenges can be mastered.

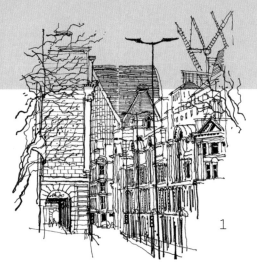

1. This extreme-perspective angle was a fast and loose location sketch that required the believability of the acute angle to make it work. I used the pen technique to get the main bones of the perspective accurate and again filled in the converging lines from there. This is a good example where the looseness of the sketch can be very forgiving.

2. This is a scene that is all about the perspective angles of the buildings in the background, combined with the scooters in the foreground. By using the pen technique, I got the two main converging horizontals in first and then built from there. I normally find that these angles are more acute than I realize and the pen does all the work for me.

3. The perspective on this rooftop sketch from my home town of Leeds is quite subtle but very important to get right, as the rest of the drawing hangs off it. I used my pen to get the main left-to-right horizontal perspective line by drawing the middle-right building. I then used this anchor point for the other horizontals. The vertical lines are pretty much straight without perspective, which was very helpful.

Measuring

Anchor measurement

Measuring while drawing is the key to getting the proportions and the structure of the elements you are drawing as accurate as possible. You may have seen the classic image of an artist holding their thumb out at full stretch and closing one eye, using their digit as a measuring device to transfer the scene accurately to a canvas. Well, that is measuring in its most basic form.

- -

The amount of measuring you do while you are drawing depends very much on how accurate you want your sketch to be. In the workshops that I run, some sketchers get tied up in knots over measuring every aspect of what they are drawing, and I often encourage people to relax a little over accuracy and go with their gut on proportions.

There is much joy to be had when proportions go awry and I wholeheartedly embrace it when things go wrong, but I do understand that for some people, wonky interpretation (as I fondly call it) can impair their enjoyment of the process.

It can therefore be useful to work out some key measurements when you are starting a drawing. For instance, getting the distance right between two prominent features can ensure your drawing feels structurally right. Working out that you can fit everything on the page before you begin is also a worthwhile endeavour. A little measuring may well also give you some confidence to jump into the drawing, knowing that some key elements are already worked out.

To measure the proportions of the scene you are drawing, you have all the measuring equipment you will ever need in the palm of your hand – your pen or pencil. Hold your pen up to your scene at arm's length, and use your thumb to mark on the pen the length that you are measuring. Perhaps it is the height of a building, or the distance between two key points. Next, transfer this measurement to your paper to create the anchor points that will ensure the basic accuracy on which to build your drawing.

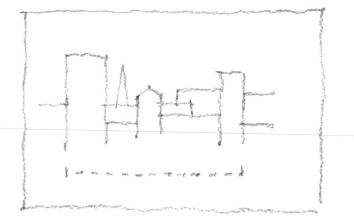

Anchor measurement

1. The key elements I wanted to frame this sketch were the crane tower on the left and the angled office block on the right. A quick measurement using my trusty pen locked in the spatial relationship between the two elements, helping me fairly accurately portray the other buildings (as long as no one is counting the windows).

2. This magnificent town hall in Malaga, Spain is surrounded by mature palm trees and I wanted to make sure I fit the tops of both the trees and the building on the page as I was drawing in an A5 drawing book. For this drawing to work, it is crucial the top of the building is on there and as I started at the bottom again on this one, a few quick measurements ensured I got the scale right, and I made sure I was allowing for some white space around the drawing.

3. While this looks like a free-flowing scene, the key to its success is the statue in the foreground and the background building, which I've given enough white space to let it breathe. I measured the height of the statue in relation to the background architecture to make sure it all fit on the page and the scale felt right.

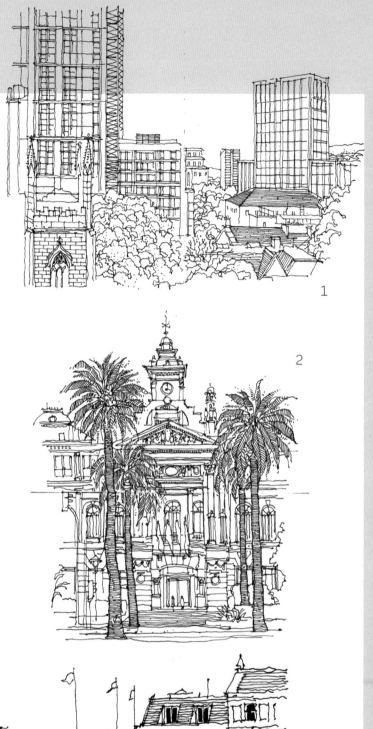

1

2

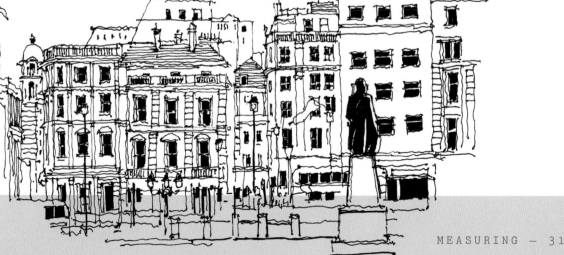

3

Composition and scale

Composition and scale are other words for the placement
and size of your drawing on the page. There is no exact
science to what makes good composition or scale, and both
are very much open to personal interpretation, which can
make them difficult to get to grips with at first.

- -

The amount of white space around a drawing can be just as
important as the drawing itself. Before you begin your
drawing, think about its placement on the page and what
you're trying to achieve with it. Do you want to fill the
canvas right to the edge to create a complex textural feel,
or do you want an airy openness? In either case, the amount
of space you do or don't leave contributes hugely to the
finished effect. The key is to be thinking about it at the
outset and have an endgame in mind for your drawing.

When composing a scene on the page, think about the
entire canvas or page at your disposal. If you're drawing in a
book then make the most of the double-page spread, or if
you're using a landscape sketchbook make that panorama
format really work hard for you. Remember to use the
simple measuring technique to ensure the scale of the
drawing is right too.

Judicious cropping of scenes can work extremely well
when you're thinking about composition and scale. Worried
that the office block on the left will detract from the
beautiful architecture in the middle? Take it out. It's your
drawing and if an element of a scene is causing issues with
the composition, then tweak or remove it. My mantra is that
you are creating a drawing not a photograph: it's an artistic
interpretation of real life, so all bets are off!

Alternative compositional ideas

1. This rooftop sketch from my flat in central London uses the bold white space of a building in the foreground to set the tone for the composition and scale of the buildings. Try leaving out something in the foreground to focus on the distance. This can create a nice tension in the subject matter, asking the viewer questions and prodding the mind.

2. This drawing is intentionally unfinished and composed in a deliberately provocative fashion. I love the unfinished parts as much as the linework – the mind fills in all the gaps. The white space is bold and challenging and one could argue that if it was ever 'finished' then it would be far less interesting. Try a few 'unfinished' compositions in your own work, and challenge your idea of what 'finished' means.

3. This is the polar opposite of the drawing above. From the beginning, I set about filling the canvas, and I love that it's a tour de force of detail with very little white space to help it breathe. I wanted the viewer to be as overwhelmed with the architectural magnificence of the cathedral in Malaga as I was. You'll notice there is some respite from the relentless details with little pops of white space to help the eye.

Lines

With both urban drawing and urban watercolours, I can't emphasize enough how important your linework is. Whether you're drawing in pen or pencil, the quality and expression of your lines provide the unique character and personality of your artwork and when you come to add watercolour, they dictate the style of the colour. My signature linework style belongs uniquely to me and I have lost count of the number of times that I have been told that it is instantly recognizable as mine. Try to cultivate a style of your own. When looking at artists whose work you enjoy, look carefully at what they are doing with their linework, and ask yourself what it is that you like about it.

- -

At the beginning of a drawing, ask yourself what style of line the scene needs to bring it to life. Should it be loose and free, or tight and restrained? Should the pen or pencil be fine and controlled, or bold and chunky? Think from the earliest stages about how you might want to add watercolour, too, but be prepared to be open-minded as the scene unfolds. How detailed does the linework need to be? Can it be sketchy or does the subject matter dictate clean, crisp lines?

Use different line weights to your advantage. I use heavier lines for subject matter that is in the foreground and lighter line weights for objects further away. This simple line technique will deliver a real sense of scale and distance.

Add character to your lines too by adding an occasional wobble. This can deliver a huge amount of believability if you can ensure this is applied consistently across the drawing. I prefer wonky lines to straight ones every time and under no circumstances should you use a ruler.

There is language in linework and it's worth experimenting to find out what yours is. Is it delicate pencil that plays second fiddle to your watercolour, or is it bold and varied black ink where the watercolour acts as a highlight medium? When you find a style that speaks to you, work hard to develop and refine it, trying different lines along the way.

1. This live sketch example is in Hackney, London and I have used a looser, craggier line here to denote the atmosphere of the location. It has historic buildings and hipster coffee shops on every corner, so I think the style in some way has to match this and convey a sense of cool history. I've also accentuated the 'wobble' on the line to extend this idea further. You will see I've also varied the line weights again to denote shadow in advance of adding some watercolour.

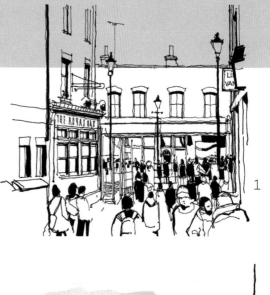

1

2. This is another good example of the employment of different line weights to deliver distance and foreground prominence. I initially draw everything in the same weight and then add heavier weights to certain lines as I go – this is a good tip if you haven't tried to vary your line weights before. This technique works just as well with pencil – use softer pencils for foreground and harder for distance.

3. There is a variation of line weights at play in this drawing, each of them doing a very specific job. The main subject matter is the pub in the centre, so I have used heavier-weight pens to pick this out. Heavy black pens denote shadow and prominence, while the thinner supporting lines provide context. While the drawing is fairly accurate, I have added some 'wobble' to deliver character in the modern buildings.

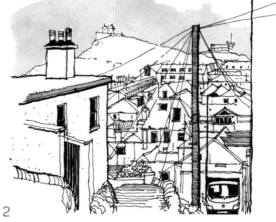

2

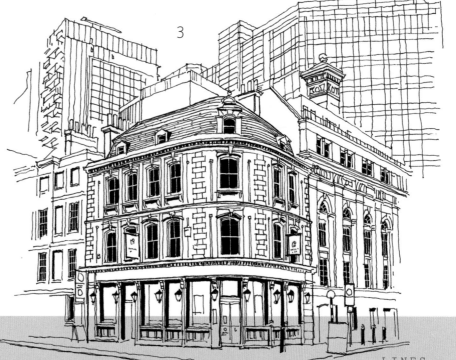

3

Putting drawing theory into practice
Exercise

I've tried to select a scene that brings together all of the four key elements mentioned in this chapter, so you can try out several techniques at once to hone your drawing approach. By bringing together perspective, measurement, composition, scale and linework all in one exercise, you will see how they all work together to deliver an aesthetically pleasing and satisfying finished drawing.

This scene is quite a complex rooftop view, but with a few simple tips and tricks, you should have nothing to fear and be able to get stuck in without any problem. Challenge yourself by finding a similarly busy rooftop scene, and apply these steps to your own image.

NOTE
For this exercise, I used a 0.3mm fineliner for the core linework and heavier-weight pens as I developed it. Any of the previously mentioned fineliners would work well here.

1

1. Because we are drawing a rooftop scene, start your drawing in the top left-hand quadrant of the page. This will ensure you can get the horizon into the drawing, while allowing the scene to develop into the bottom of the page. If you start too low or too high, there is a danger that you will miss off the key elements of the view. Start off in the centre and build from a key point. I'm using a single-weight fineliner in the first instance, with no pencil, but you could use any medium in this exercise. Remember to begin by taking a few key measurements, before setting pen to paper.

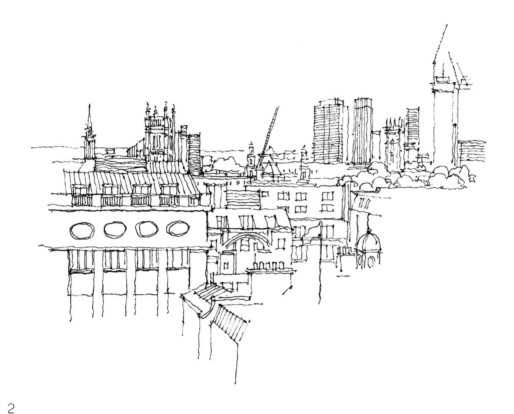

2

2. Keep building from your starting point on the page, and continue to use your easy measuring technique to make sure you are keeping the important landmarks in your drawing in proportion with each other. I'm paying particular attention to a cathedral in the centre distance and the tower blocks at the back, as they will set the tone for the composition. By measuring these key elements, you will ensure everything is in the correct scale and proportion. Perspective is very forgiving in this particular instance, so enjoy the luxury and just focus on the lines that come towards you, left and right.

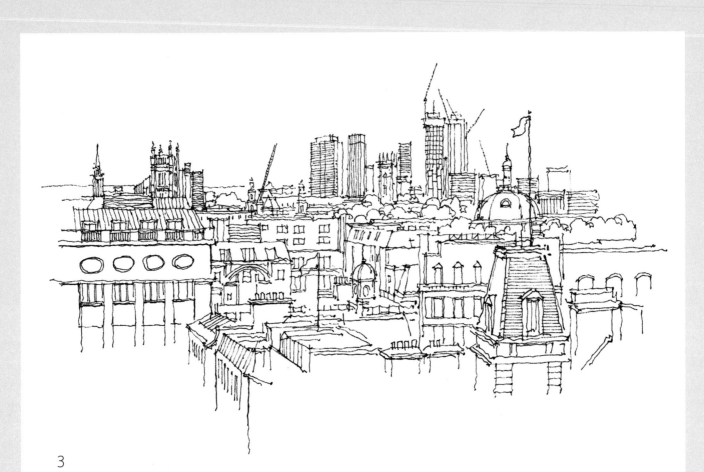

3

3. I'm building this scene out quite quickly now, and you can see how the wobbly lines are driving the character of the drawing. Don't be tempted to go too 'tight'. You will see I'm still staying with a single line weight as I sketch for consistency. I will add more weight and depth to the foreground lines when we get to the next stage. You can also see that I'm not really worrying too much about accuracy and detail as we build out the drawing –

I'm more interested in the view as it develops to the right and left of the starting point. The scratchy nature of the pen on the paper is enjoyable and the inconsistent line works well with the hard lines of the architecture, so I'm pushing on with that. Be mindful at this stage of white space around the drawing and think about what you put in and, more importantly, leave out.

4. I decide to call time on the drawing at this stage (which is never easy) and add some solid blacks and heavier lines to denote depth. My instincts told me to focus on the top half of the canvas and not fill the page, so I have left the bottom half clean, which helps push the horizon line into the distance and give a sweeping scale. I also wanted to achieve a lovely wide landscape feel to the finished linework, and the white space around it delivers this in spades. Note the solid black technique I used for the windows (works a treat every time and gives a rhythm to the work) and the slightly heavier lines in the foreground to give weight to the objects nearest to me. We'll add watercolour to this drawing later in the book (see page 58).

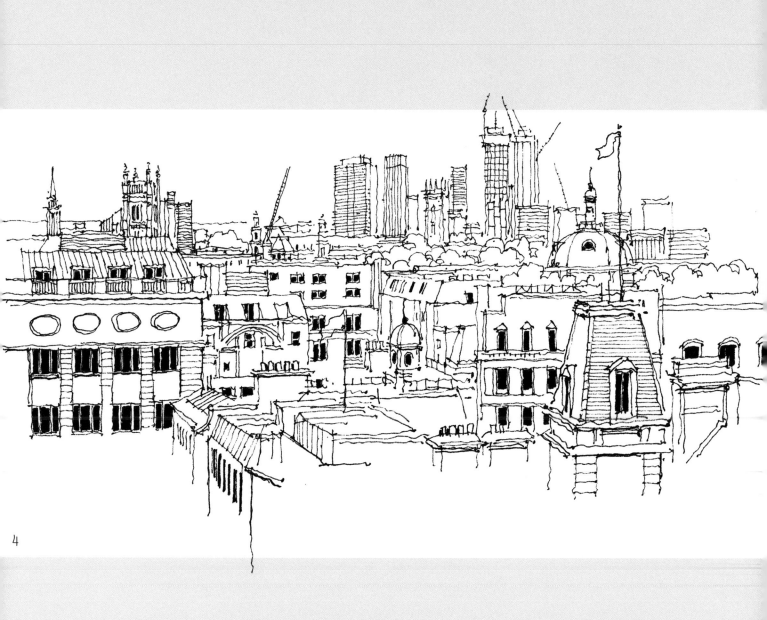

4

Loosening up

Watercolour is a style of painting that can be very tight and precise or wonderfully loose and free. In order to achieve either of the above or the huge range in between, I always advise a few quick loosening-up exercises. These will help you be more confident with the medium and free you up to have fun with it. This looseness will translate beautifully into your line and brushwork.

Creating 'thumbnail' sketches is an age-old method of capturing subject matter quickly and concisely without worrying too much about detail too. This technique works very effectively with watercolour, where you can experiment with line style and colour combinations.

Getting started

We have talked about how working with watercolour in an urban environment requires a degree of planning to make sure you get a great result. But once you have the right equipment and materials to suit the subject matter and location, there is little to stop you painting whatever you find interesting.

- -

There is merit in spotting locations in advance and noting them down for future reference. I always scope out a location that I like the look of – what is the best angle? Try sitting and standing – can I get higher? Does the subject matter look better at a three-quarter angle, or straight on? Try not to settle on the first angle you get to or one that is easy for you. Take some reference photos on your phone if you're not painting it that same day.

Try not to overthink this part of the process, and remember that unexpected joy can be found in the most underwhelming views. Go with your artist's instinct and if the view isn't working, move around and find another angle.

I mentioned London artist David Gentleman in my previous book *Urban Drawing* as a fantastic example of an artist who expresses his view of where he lives beautifully. I wanted to mention him again here because he excels at selecting the right angles of endlessly interesting subject matter. He is a first-class exponent of watercolour in its purest and most immediate form, and his work is almost journalistic in the way he tells the stories of London's neighbourhood. There is much to be learned from how he treats a wide range of subject matter – his approach is a masterclass in how to use watercolour to interpret different scenes and settings. I recommend you look up his work and take inspiration from some of his techniques regarding location.

What to draw?

Sometimes, there is just too much choice when deciding what to paint. That's why attending urban sketching workshops where the subject matter is presented to you can sometimes feel very freeing, as you do not have to decide the subject yourself. Here, I've outlined a few subject ideas that help me get the pens and brushes out, and hopefully it will do the same for you.

Go higher

Watercolour is the perfect medium for capturing a city vista. Get high up to get a feel for the urban landscape – the roof terrace of a hotel or the top of an accessible shopping mall or car park are just a few examples of vantage points that can help you to see the city in a different light. Any kind of elevated position will give you a different take on any scene, and it is always worth investigating.

Unexpected combinations

Cities grow and expand across different time periods and provide a varied and exciting mix of old and new, manufactured and natural. I'm always on the lookout for urban collisions of the classical and the modern as they make for fun and interesting subject matter.

Keep an eye out for interesting combinations of architecture and nature. For instance, the organic lines of trees provide a soft counterpoint to the hard lines of construction. You may well be surprised by how green your city actually is when you start painting it in watercolour.

On the move

Travel has always been a great inspiration for watercolour artists and it should be no exception for you. Watercolour painting is not impossible to do while travelling, you just need the right kit to capture scenes on the move. An all-in-one fan set of colours can be most useful for painting on the hoof (see page 13).

Inspiration for subject matter while travelling is vast. Why not use your waiting time, whether it's in an airport lounge or a train station, to create a journal of your trip? I always plan any travel around suitable drawing and painting subject matter, so regardless of where you're going, make sure there's plenty of sleepy old towns or vibrant city views to add to your collection.

And when travel is off the cards, don't forget that you can still use photographs to inspire your watercolours, and transport you back to past holidays and trips.

Ordinary = extraordinary

A scene that you wouldn't ordinarily look at twice can still be amazing in watercolours. The freedom of the medium can completely transform an ordinary scene: locals sitting outside a bar drinking cocktails in the sun; fast-food delivery drivers waiting for their orders; a sign on a wall advertising an upcoming concert. Watercolour brings a level of artistic interpretation to everyday activity and run-of-the-mill subject matter that might look dull as a photograph. Remember, watercolour opportunities are everywhere, it's just a case of staying attuned to them.

- - - - - - - - - - - - - - - - - -

TIP
It's easy to be
overwhelmed with a huge
city vista if you're
just getting started, so
begin by zooming in on
one building or another
individual element of
the scene, and build out
your scene from there.

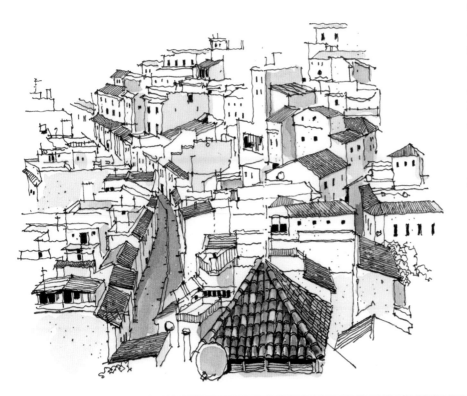

Thumbnail sketches
Exercise 1

The purpose of this exercise is speed and confidence – we're not worrying about accuracy or realism. The aim is to capture the essence of the subject swiftly, so pick out a fat brush that has a fine point on it but is also quite chunky. You will only be using one brush, so I want you to experiment with the brush weights, turning and twisting it in your fingers as you move swiftly to capture the scene.

Keep the watercolour to a limited palette of two or three shades and don't put any wash on the drawing. Think of this as a line-drawing pen or pencil but using a fat brush and watercolour.

Work in a watercolour book no larger than A4 (ideally one that lays flat) to keep your sketching fast and focused. Find a location with multiple angles and views. Try to vary the scene in each of your sketches – for example, a close-up of a plant or tree in the foreground in one sketch, and a particular feature of a building in another. Allow yourself five minutes to capture each view.

● Start making marks immediately, beginning with a single point in the middle of the scene and work out from that point. Don't worry about the structures and perspective of what you're drawing – just start at a point and build from there.

● Try to build in varied line weights using one brush. Experiment with thin and fat lines to accentuate elements in the view. Don't worry if you make mistakes – speed is the essence of this exercise.

● Aim to look at the subject matter for double the amount of time you are looking at the page. The more you look, the better your sketches will be. Once you've got the basic shapes down, add detail to build up your sketch if you have the time. While the watercolour is still wet, experiment with a few splashes of water to add character and immediacy to your work.

● Try to include as many details as possible in the time you have, but don't labour your marks – keep your movements quick and relaxed. When the timer sounds, turn the page and go again with a different subject and medium. Repeat this exercise three or four times and you will be surprised by how quickly you become more relaxed about the results. This looseness will help your watercolour artworks immeasurably.

NOTE
For this exercise, I used a Pro Arte Masterstroke Series 60 – an inexpensive synthetic brush that delivered a smooth and expressive line.

TIP
This exercise can be done just as well at your desk as out and about on location.

Start at
a point and
build from
there.

Try to build varied line
weights just using one brush.

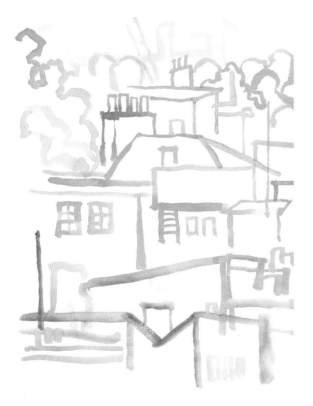

When you have the basic shapes,
add more detail to your drawing.

Try to include as many details as
possible in the time you have.

Drawing people
Exercise 2

People are the most important and integral element in any city, and it is worth getting comfortable with sketching them as you embark on your urban-sketching journey.

In an urban setting, drawing people can be very challenging because they are constantly on the move. Find a location where there are lots of people doing different things, for instance a high street, train station or airport. The key is to position yourself out of the way so you can focus on the job at hand. Remember, the idea is to be fast and fearless and again, we're not worrying about accuracy.

You will need a large, soft pencil – at least a 4B, and ideally a chunky lead clutch pencil or even a large chisel pencil. You will want an expressive pencil line and not something fine or hard that will encourage you to be too detailed. Remember to bring along a pencil sharpener or sandpaper block to keep your point sharp – fast sketching wears down the point on the lead very quickly. Pick out a small A5 watercolour sketchbook that is portable.

2

2. Add relevant detail and any elements from the background that add context. While this is purely a pencil exercise, try to imagine where the colour might be added. Build up your scene with multiple drawings across the spread of your sketchbook.

1

1. Find your preferred location and get yourself set up and comfortable. Try standing by a low wall where you can rest your book and equipment, rather than sitting down. Standing to sketch will naturally deliver a more expressive line, so do give it a try if you are able. Set a timer for ten minutes and start by sketching quick outlines of people you can see – be fast and loose with the line. Focus on the head at first and draw down from there. Remember to keep your eyes on your subject as much of the time as possible.

- - - - - - - - - - - - - - - - - -

NOTE
For this exercise, I used a Koh-I-Noor clutch pencil with a 4B 4mm lead. Lovely and weighty in the hand, it encourages loose and sinuous lines. For the watercolour, just use a basic set of pans to add colour, such as Derwent or a Shoreditch Sketcher fan set.

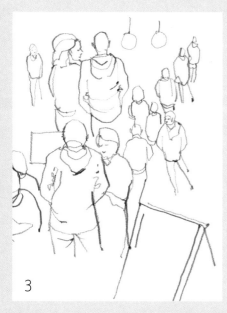

3

3. Mix up the weights of your line –
use bold and chunky lines alongside
fine and delicate ones. Think about the
composition of the people on the
page as you draw them. Your drawings
will look rough and ready, and wildly
inaccurate, but embrace it.

4. Splash a few background
watercolour washes on the pages to
give the drawing depth and context.
Look at where the shadows are falling
and try to keep the shadows consistent
across each figure. Instead of using
lots of colour, just use some greys for
depth or a few pops of colour.
 After ten minutes, your drawing
book spread(s) should contain multiple
people drawings. Reset your timer,
move to another location and repeat
the exercise with a different scene.

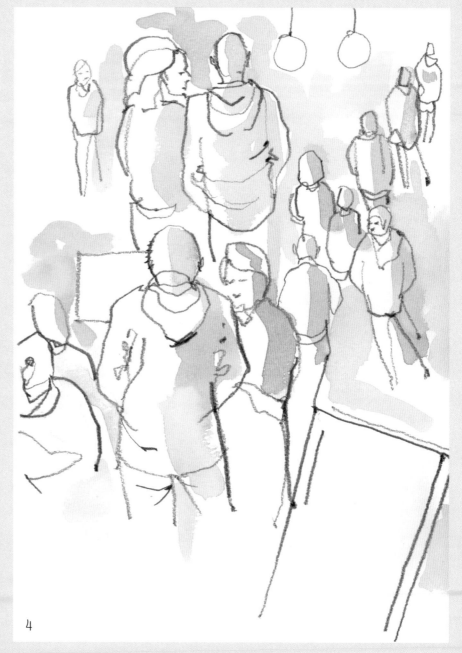

4

Blocking shapes
Exercise 3

This is another exercise that will help you learn to work speedily and confidently. Here, we are going to work with just watercolour without any linework component whatsoever. This exercise will help you look at the structural shapes of the architecture more carefully, as you don't have the linework to help.

Identify a location where there are distinct shapes and elements in the subject matter. Rooftops are ideal, as you have a combination of shapes and sizes, all sitting next to each other. Use a limited set of watercolours and only a couple of brushes (one large and one small) to complete this exercise.

1. Set a timer for 15 minutes and start interpreting the shapes you are looking at using watercolour paint. Look closely and don't make anything up – try to visually describe the shapes as accurately as possible. It's quite tricky using just a brush so use a thin brush for the detail.

2. Move across the subject matter and, while maintaining accuracy in the shapes, try changing the colours. You could use the same colour across the entire scene, or experiment with colours that relate to the subject matter – blues or oranges for the roof tiles and grey for skyscrapers. Work quickly and splash the water around liberally. Most of the focus in this exercise will be on getting the shapes as accurate as possible in the time you have allocated.

3

3. Tackle each shape as it occurs next to its neighbour, moving left to right or up and down. I find this technique helps me stay focused and not get lost in the subject matter. If you have time, add some finer architectural details or darker tones to the foreground.

When the timer finishes, think about what you would do if you had a further 15 minutes. While the primary purpose of this exercise is speed and agility, you could take your illustration further by adding more detail in the form of pencil, line or watercolour pencil.

— — — — — — — — — — — — — — — —

NOTE

For this exercise, I used
Pro Arte Masterstroke Series
60 round brushes. For the
watercolour, you could just
use a basic set of pans such
as those by Winsor & Newton.

Getting started with watercolour

There are so many techniques available to the watercolour artist that it can seem overwhelming to the beginner. In this chapter I want to show you some basic techniques that will get you started on your watercolour journey, and that will hopefully inspire you to explore the medium further. I aim to demystify some of the core language and techniques to make the medium more accessible and less intimidating.

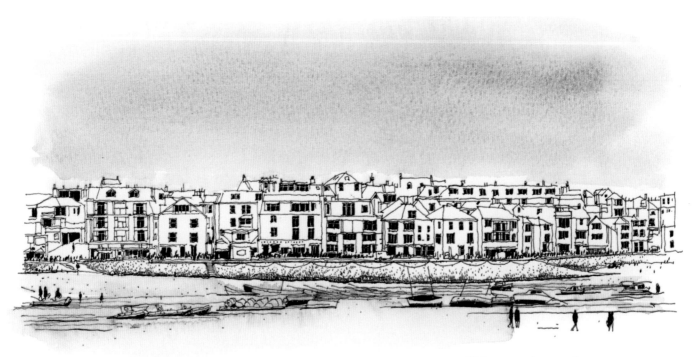

Wet on wet creates a
beautiful bloom effect.

Layering creates depth.

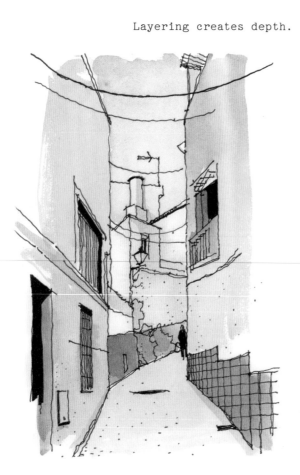

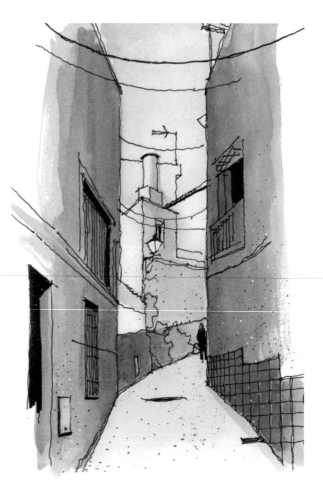

Core techniques

Watercolour is fundamentally a simple medium, but it does require some knowledge of the basics to create satisfying artworks, and together we will explore a number of ways to achieve this.

- -

Wet on wet

For epic skies there is no better technique than wet on wet. And it's so easy! Simply load your paper with water and then load the top of the wet area with well-diluted watercolour paint. Watch as the colour seeps downwards to create an unpredictable and beautiful bleed effect when dry. Just make sure that it's fully dry when you work on it as otherwise the colours will continue to bleed everywhere.

Layer up

Watercolour works best when built up from light to dark, so go easy on the colour and layer it up carefully. Knowing how far to take it is a balancing act, but the more you practise, the better you'll get at making the call when enough is enough. Because watercolour is a 'thin' medium, you can build the colours as you go and mix on the page, allowing you to layer the pigments to create interesting effects.

Limit your colour palette

Resist the temptation to use lots of colours. Using fewer hues will not only make life easier for you, it will also yield better results. Keep it simple and use a limited amount of colour – or go for a monochrome look. Try using just one hero colour in a painting, or shades of that colour, to create a minimal, dramatic effect.

A limited colour palette creates a strong visual image.

Rough and smooth

The correct use of paper is a technique in and of itself. The 'toothier' the paper, the more textural the finished watercolour will be. If you want a rugged and characterful feel, go for a rougher paper. On the other hand, if it's important to depict objects more accurately, a smoother paper finish will give you the surface you require.

Bleed colours into each other

Achieving a wonderful 'bloom' in watercolour is the result of working into a wet colour on the paper with another colour. This allows you to blend and create subtle gradients in the finished colour. The joy of this technique is that you never quite know what the end result will be, and that is part of the fun. Don't be afraid to be creative and experimental.

Splashing around

Don't be afraid to splash around the watercolour and use your brushes and pens to create spontaneity and movement by using splats, drips, blobs and splodges. This is a fun and energetic technique that can really add excitement to your watercolours, particularly loose drawings and sketches.

In this example of rough and smooth, you can clearly see how the paint sits on the toothier paper, creating a satisfying effect.

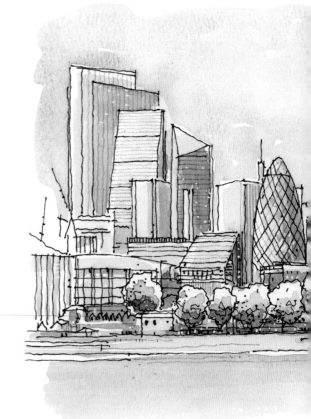

Try bleeding
different colours
into each other,
perhaps colours
you wouldn't
expect to work
together.

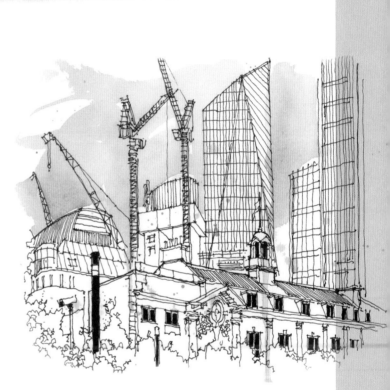

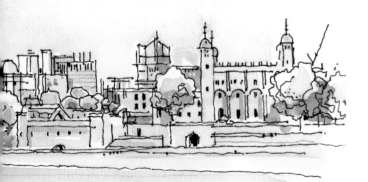

This painting is the result
of bold application of
watercolour and spontaneity.

Loose line and watercolour Exercise 1

In this exercise, we're going to take an existing line drawing in either pen or pencil and look to add simple watercolour to it. If you've never tried watercolour before, this is the perfect opportunity to dip your toe. One key point to remember with line and wash is that it's not a simple 'colouring in' exercise, where you fill rigid spaces with colour. The lines should provide a framework, but the linework and the colour should be harmonious and work together, rather than one dictating the other.

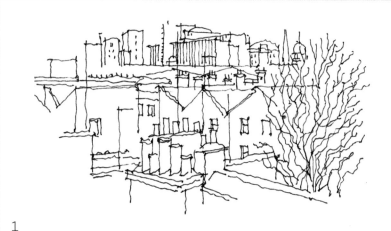

1

2

1. Begin by thinking about the linework in your drawing, and how that might affect the way in which you apply colour. If the lines are fluid and sketchy, you may want to apply the colour in a similar way, and not worry too much about going over the lines. On the whole, you will want to avoid 'filling in' the colour, as this may give your work an unintentional 'paint by numbers' look. I sketched this rooftop view quite quickly, hence the very loose lines (I seem to recall it was a chilly November day). I chose to use a limited palette to draw this scene, due to the time of year and the urban subject matter. Note the white space left on the page to draw in the eye and let the drawing breathe.

2. The foreground is a good place to start with rooftop scenes, to aid you in judging the weight of the colour. I keep the foreground colours brighter and stronger than the colours in the distance, which helps give depth and scale. I'm aiming to keep the colour quite translucent here, so I'm adding plenty of water to the paint. I want to get the 'bleed' effect when it dries to add texture and mood. In this instance, I don't want the colours to be too flat and precise, so I'm using a large, round 10 watercolour brush as I'm trying to match the looseness of the linework. A good tip is to use the same colour two or three times in different parts of the painting to tie the scene together.

3. Don't worry too much about being entirely faithful to the colours, but keep them pretty close to real life to make the scene believable. Next, I add the pale grey of the roof tiles and soft blue of the modern buildings in the background, keeping the colours pale and washed out to make the foreground pop. For this effect, select a blue or black and add lots of water, testing it on your palette or swatch paper as you go. If you add too much colour, dab it off with a dry brush or paper towel. I roughly follow the form of the buildings with a slightly darker hue of the colours to create a layered sense of depth. In this case, I don't add any sky colour as I want a white sky to make the rest of the colours pop.

4. Finally, once the painting is dry, I add some detail on top of the watercolour. Some purists may not condone this approach, but it's my painting and I'll do what I like! I use a soft pencil (4B or similar) to add some loose detailing in the foreground on the roof tiles. I also use a white gel pen (you could also use white gouache) to add some brickwork detailing on the chimney stacks. A good tip for creating depth is to add some detail in the foreground and no discernible detail in the distance. The little details make all the difference in this instance, so always be thinking about adding a few flourishes.

– – – – – – – – – – – – – – – – – – – –

NOTE

For more advice on the composition and drawing of your initial urban sketch, see page 32.

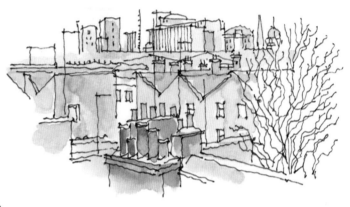

3

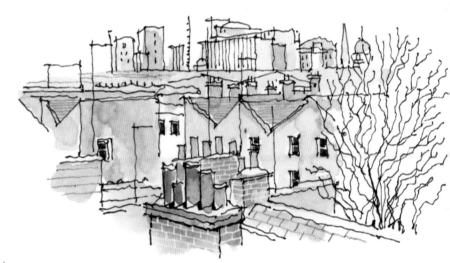

4

Tight pen and watercolour Exercise 2

In the previous exercise, we kept the wash loose and fluid to match the nature of the lines. In this exercise, I want to show you how to paint watercolour in a restrained and more accurate style, although we will still be staying true to watercolour and taking full advantage of the medium in terms of blending colours and shading.

Line and wash is a broad church and there are many different takes on it. Use these exercises to experiment and find your own style and what you're comfortable with – and have fun trying different things along the way.

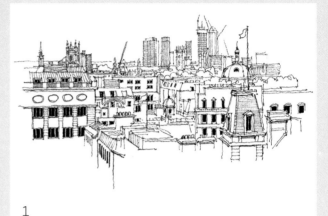

1

1. You will recognize this drawing from the exercise in Chapter 1 (see page 39) and this is a good example of tight linework that still retains an element of character in the line, and is perfect for a restrained watercolour painting. The style here helps dictate how to add the watercolour and provides a rich vein of subject matter to experiment with. For your initial sketch, try to pick a rooftop scene with relatively tight linework so you can follow along with my steps.

2. Using a round 4 brush, start by adding the greys of the rooftops, using the same colour to tie them together. Although I'm still aiming for a level of translucency, I'm trying not to have too much water splashing around as I'm going for a dryer feel to the colour. Next, I added the blues and greys of the towers in the distance, making them paler to give a sense of distance.

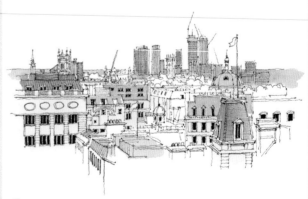

2

3. Add the pale cream colour of the building stonework. By building the colour up this way, you will learn what colours work well together and you'll get a good feel for what to add and what to leave out. While the wash is largely staying true to the lines, allow the watercolour freedom to roam where appropriate, such as at the bottom of the drawing.

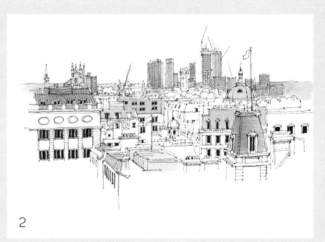

3

4. Mix some green and bring the trees to life. When I drew this, I didn't notice that there were so many trees and the green adds a lovely ribbon of colour that adds a perfect counterpoint to the greys. I always think of trees as green clouds when I'm painting with watercolour and treat them accordingly. With a lighter colour at the top and a touch darker at the bottom, load up your brush and work loosely. Remember, the trees are in the distance so this renders them a feature of the scene, not a focal point.

5. For the finishing touches, I strengthened some of the foreground colour to bring the tower on the right towards the viewer. I also added some extra weight to selected linework, using a thicker fineliner pen. This creates the effect of pulling the foreground nearer and pushing the background further away. Finally, when the painting was dry, I added some pops of white throughout to create highlights on the trees and towers in the distance, and the detailing of the windows.

4

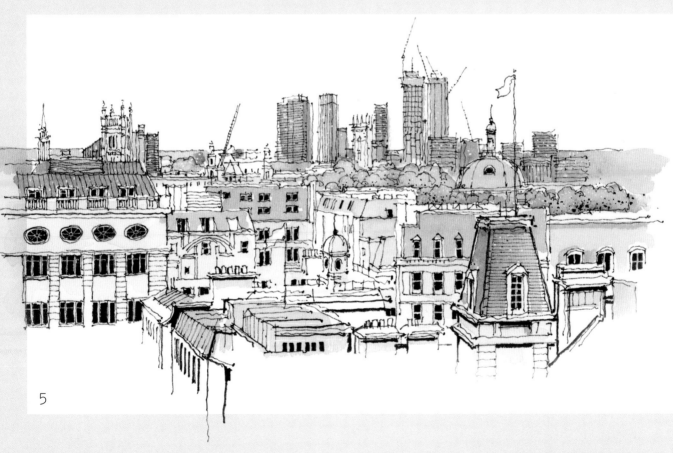

5

Pencil and watercolour Exercise 3

The first two exercises in this chapter demonstrate the effectiveness of graphic black-and-white pen drawings combined with watercolour wash. These next two exercises take a look at how pencil and watercolour work together to create a very different effect. Many beginners prefer to use pencil due to its forgiving nature, so if you are new to watercolours, it might well be the perfect medium to get you started.

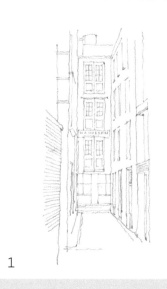

1

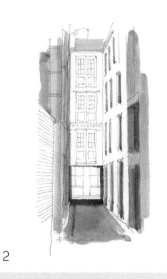

2

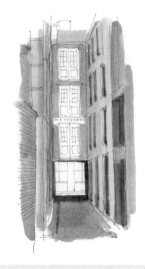

3

1. I was intrigued by this portrait view of an alley in my local neighbourhood. I loved the converging angles and the factory doors and bridge over the alleyway. I drew it using a loose style with a chunky 4B pencil. I wanted a softer feel to the lines, as I wanted the watercolour to do all the talking. I didn't put too much detail in the drawing for the same reason, and because I knew that more detail could be added after the watercolour.

2. Using a large 10 round brush, I started with the grey and darker shadows, looking carefully to see where the light was coming from. The shadows denote the light source so it's key to get them right, as it sets the scene for the rest of the watercolours when they are added. There is quite a lot of blue in shadows (especially on a sunny day), so you may wish to add blue to your black to give your shadows depth and reality.

3. The brickwork comes next and the warm tones of the building materials contrast nicely with the greys and blues as they are at opposite ends of the colour spectrum. Feel your way with the colour – what do I leave out? Is there too much colour here or not enough? Take your time adding the colour and recognize that sometimes less is more.

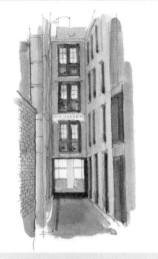

4

4. The blue paintwork at the end of the alley is the main focal point so I carefully put this colour in using a smaller 4 round brush. I was keen to keep the application fairly loose, but the detail on the doors did necessitate a little more care to get them right. I also added some more pencil detail at this stage, once the watercolour was dry, by beefing up some of the foreground door and window linework and adding deeper tones to the shadows. Adding the brickwork detailing on the left creates a point of interest to draw in the eye.

5. The final stage involves building up the depth in the shadows using darker tones of the black, grey, brown and blue. If you take your time to carefully add these layers using plenty of water with the paint, you can't go wrong. With watercolour you can always add more colour, so start pale and build as you progress (if you start too heavy it is difficult to go back). I used white gouache paint to pick out some of the highlights to create definition in the door and the railings, and the odd brick here and there.

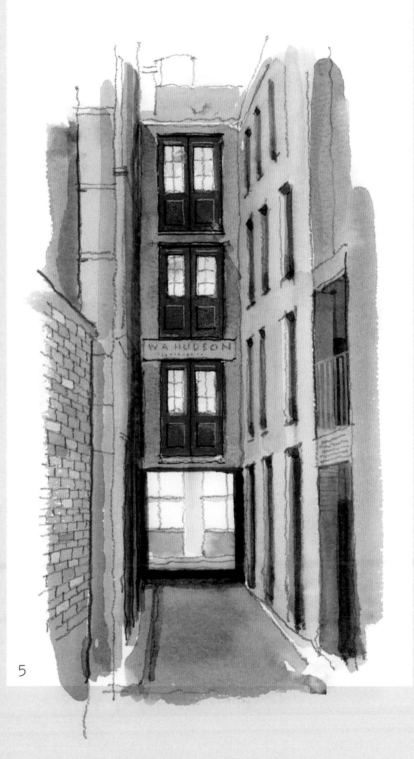

5

Building up layers of colour
Exercise 4

The previous exercise demonstrates the effectiveness of building up colour and not committing too early to the eventual depth of the colour and hue of the artwork. This exercise focuses on simple techniques to create satisfying depth and interest in your watercolours. The criticism often levelled at watercolours is that they're wishy-washy and too 'chocolate box' – too timid and pretty for their own good. Well, this exercise aims to dispel that notion.

1

2

3

1. Start with a large wash background. I used the biggest brush I have (a 10 round) and experimentally laid down a large expanse of paint in two colours. I wanted lots of bleed so used plenty of water first and added paint on top (for more on this technique, see page xx). This first layer features all manner of textures and bleeds, and it will provide the perfect backdrop to the next stage of this sketch.

2. Start drawing on top of the colour, in this case using a 4B or 5B pencil. Be expressive with your lines – the surface of dried watercolour on a toothy paper with take your pencil lines very well and the harder you press on, the blacker the lines will be.

3. Try not to let the background colour wash influence what you draw, and try to just use the background as an abstract effect to build on. It's a fun way to work and, as you draw, you can experiment with line weights and happy interactions with the wash.

4

4. Once you're happy with the pencil linework, assess the overall structure of the drawing and work out what is needed next. Deeper tones? White highlights? I added some white highlights and features on the grey and yellow to provide definition to the architecture. After I added the white, I thought the lines would benefit from being blacker so I made them bolder. This is the beauty of starting off light – you can always add boldness, but you can never take it away once you've made the mark.

5. The final stage was to add more depth to the windows using greys and blues. You can see from the previous stage that while the windows looked perfectly acceptable on the flat grey, they were definitely missing something to make them pop. I achieved this by using a combination of strengths of the blue and grey, building colour depth and creating interesting reflections. The result is that the intimate jumble of buildings are captured in an interesting and creative interpretation.

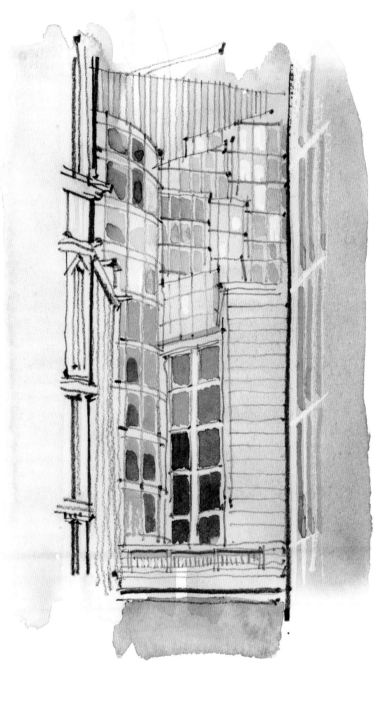

5

Everyday objects

Urban watercolour is not just about the cut and thrust of
the city, it is also about the depth and texture of the
urban environment. In this section, I want to encourage you
to look for the small details that make the urban
environment such a rich subject for the artist. By focusing
on these details, you will be able to study their form and
function in larger scenes, and at the same time, experiment
with watercolour in a very different scenario.

- -

The study of everyday objects is just as exciting as big vistas
– they all have their own story to tell and watercolour is
particularly effective at telling it. These are the small stories
that will allow you to get some solid watercolour practice
under your belt in a less challenging environment. You'll be
able to sit quietly in a church or café, capturing the details
that surround us all.

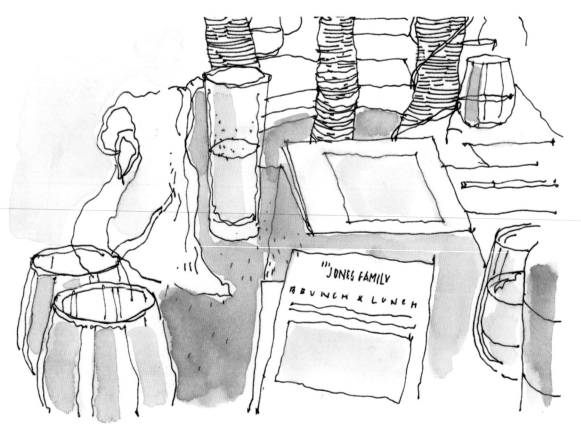

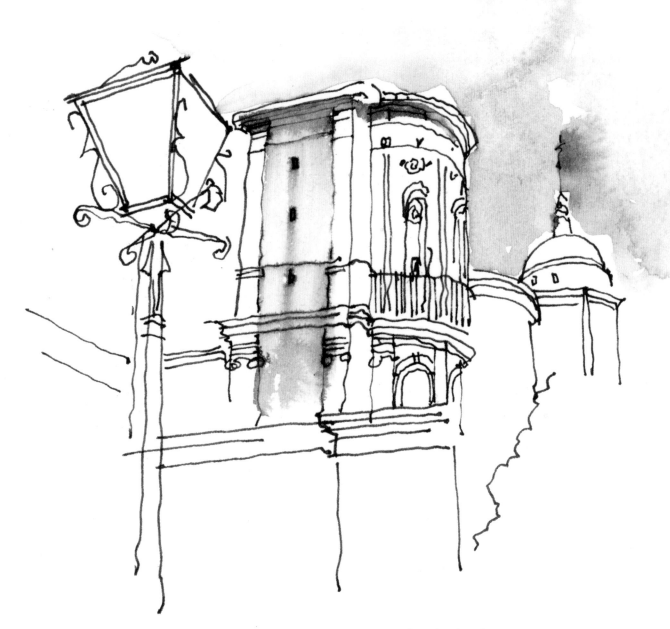

◀ On the move

Travel creates great opportunities for detailed watercolour studies – not just the obvious destination watercolour but the intimate details on the journey. The train or plane journey, the airport or train station. An hour spent in a lounge here and there, waiting for travel and the ephemera that surrounds it. Get it all down on your page.

▲ It's all in the detail

As an urban artist, you will be familiar with taking notice of everything around you, but I want you to look even more closely at the city you live in. You will discover the architectural details that are only seen when you properly look. From the modern glass towers and the skeletal steel structures that contain them, to the intricately carved stone masonry that adorns churches and cathedrals, I want you to capture them all.

Food and drink

Watercolour really lends itself to the illustration of what we eat and drink; the soft fluid colour is very effective at rendering food, for instance. Whether it's line and wash or more simple watercolour highlights, it's fun to paint your food and it really adds to the journalistic aspect of what we do. There's no finer way of recalling a memorable meal in a wonderful location than in your watercolour drawing book.

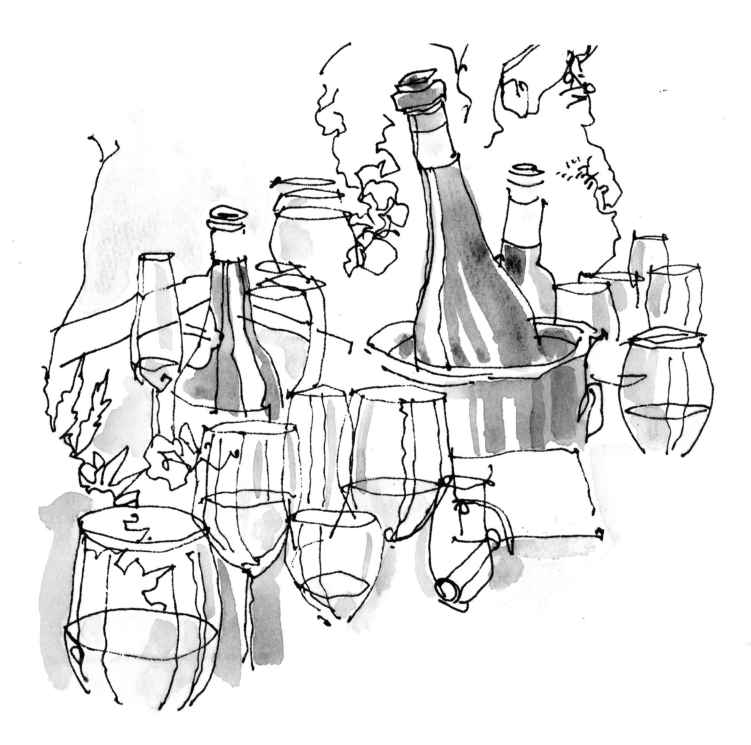

Boring stuff?

There is no such thing as boring, irrelevant subject matter. It's all fair game, as far as I'm concerned! The contents of your bag (or someone else's on the train), what's on your desk or kitchen work surface, cups of tea and biscuits, stacks of books or piles of sneakers... the list is endless and it is endlessly interesting.

Everyday objects
Exercise 5

In this exercise, we're going to examine how to bring something to life that's right in front of you on the table – in this case, your lunch. The advantage of painting a watercolour in this situation is that you have control over every aspect of the set-up, unlike when you are out and about. In addition, you can take your time to get it right (unless you are very hungry, of course). Painting food is a great way to hone your watercolour skills and try out a few different techniques. I have used minimal line and, as a consequence, the watercolour has to do all of the work, which is the right approach with the organic nature of the subject matter.

1. I have selected an attractive bowl of moules marinières with a crisp white wine as the subject matter for this exercise. Using an HB pencil in order to keep the lines light and accurate, delicately draw the scene in front of you. Try to keep the lines fluid and not 'chiselled' – a single fluid line is the ultimate aim. Your pencil lines will only act as the guide for your watercolour.

2. Begin, as always, by building up the colour in a particular area. I've started with the liquid in the bowl. Starting here helped me to define the shapes of the mussels and helped when I came to add the blue. I've added a little depth in the cream to denote the shadows the mussels are making, and will probably build this up later.

3. Go in with the dominant colour – for me, this is the dark blue of the mussel shells. I built it up carefully, and mixed dark blue and black with water until I was happy with the resulting shade. Let this dry and reassess if you need to strengthen (the paint looks a lot darker when it is wet). I looked carefully at the mussel shells to see where the shadows are and darkened my watercolour to match them.

4

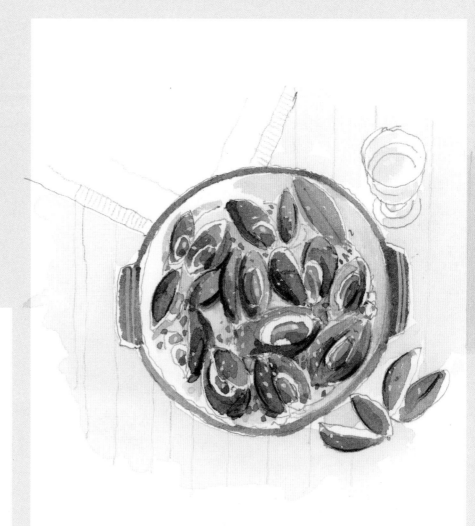

5

4. The next important colour in my scene is probably the vibrant orange of the mussel in the shell, so I mixed up a bright orange using a clean red and yellow. Don't go too vivid initially, remembering to layer it up as you go. I popped in some of the herbs using a sage green colour so they don't look too prominent.

5. Add the surrounding tabletop colours and textures using pencil. When everything is dry, assess the depth of the colours and build them up. Because there is no linework to speak of, the shadow colours will need to be strong to give definition to the shapes of the drawing, so keep tweaking. I added some white gouache when everything was absolutely dry to denote highlights in the shallots and on the shells – it made all the difference.

Townscape, greenery and people
Exercise 6

In this chapter's final exercise, I wanted to explore how to tackle a busy urban scene containing buildings, greenery and people. The combination of these three subjects will confront you pretty much every time you step out of the door, and I thought it would be helpful to show how I tackle this. There are, of course, many different ways of approaching these combinations and this is just one way to do it. My approach is tried and tested, and you should feel free to adapt it to your style.

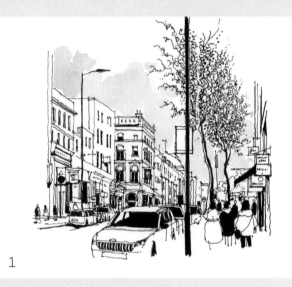

1

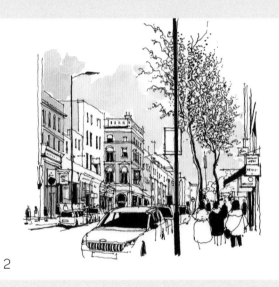

2

1. You can see at first glance that this is a very busy and challenging scene to draw. I got comfortable on a bench and did my best to capture the scene using a fineliner waterproof pen first. The focal point is the perspective of the buildings running away to the left, with the added complication of the buildings set on a hill that runs off in a different direction. Once I had the bones of the drawing, I added weight and blacks to give an almost graphic novel feel. The first touch of colour that I added was some pale blue using a round 10 brush to denote the sky. Notice how I have left little white spaces with the loose application of the colour, denoting clouds and movement.

2. Using just two warm, contrasting colours for the sky, I added some colour to the buildings on the right using a mid-sized brush, alternating the colours. Keep these colours pale for the moment and build the strength as you add more colour. The key to this scene is keeping the palette limited so it feels fresh and not overworked. I mixed up some black and diluted to a mid-grey for the bottom half of the buildings.

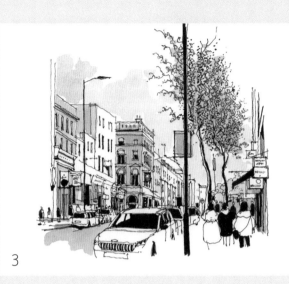

3

3. Using the diluted black and a round 10 brush, I added more depth to the road and sign to represent the shadows. I built some depth in the colours, all the while remembering to keep the stronger tones in the foreground. The green colour is now added, but keep these to the subdued end of the green scale so they don't feel too artificial. The texture linework of the greenery is doing all the hard work here and the green is filling out the visual narrative. The specks-and-dots technique for the tree lines works really well with watercolour, almost filling in the cognitive gaps. In general, try to use some restraint with the colour, leaving white spaces to allow the colour to breathe.

4. I continued to build the green tree colour to make it prominent due to its proximity to the eye. It is worth using two or three shades of green, dark and mid, to give the effect of weight and shadow. Adding the odd pop of yellow also works well, as does using different shades of blue for supporting colours, being conscious not to introduce any discordant hues. When I was darkening the tree, I decided that a few splashes and splats would bring some life and energy to the scene – don't be afraid to be bold and add this as a finishing flourish.

4

Taking your watercolour further

Once you've mastered the basics of watercolour, there are a plethora of more advanced techniques to learn and utilize in your urban watercolours. While some watercolour techniques can end up being overcomplicated and not hugely suited to urban situations, the good news is that there are plenty of other very satisfying tips and tricks that you can employ in your everyday drawing to take your work to the next level.

Once you have an understanding of what you enjoy when painting with watercolour, you can start to feel confident in exploring the medium further. The following tips, tricks and techniques are worth trying out next time you're out and about — plenty are very much achievable on location on a busy street corner, but you may well find that others are easier if you're at home at your desk or kitchen table.

Advanced techniques

The list of so-called advanced techniques in watercolour could
go on forever, so I have tried here to curate a selection of
techniques that I think you will find fun, interesting and
useful in your watercolour work.

- -

Negative space

This technique is all about what you leave out, and not what
you put in. Watercolour is a very illustrative medium, and
you can push the boundaries and just use watercolour and
white space to do the job for you. It does require a degree
of confidence and technical forethought, but by no means
do you need to be an expert. We dabbled with this in
Chapter 2 with the blocking exercise (see page 48) – this is
a great place to start if you are feeling nervous about this
technique. Just try leaving subject matter out as you draw
with your brushes, and discover how satisfying it is to let the
white space do all the work for you.

Flat wash

While there is a lot to be said for watercolour's ability to
bring beautiful texture and organic layers to your artwork,
sometimes a drawing calls for a super-flat wash (by flat I
mean very little variation in the colour as it lays on the
paper). Getting a flat wash isn't as hard as it looks, you just
need to mix enough of a colour in the mixing pan and use a
very dry brush to begin with. Make sure your water is clear
and the brush is clean, to make sure that the previous colour
doesn't contaminate your flat colour. The secret is to use as
large a brush as you feel comfortable with – a smaller brush
will result in more visible brush marks and a larger brush will
deliver the flatter colour. Of course, gouache will deliver the
flattest colour you will ever need, but it's nonetheless useful
to practise with watercolour.

Flat wash

Granulation

Granulation medium is a liquid that you can add to your watercolour when you want a granular feel to your wash as opposed to a flat effect. Granulation medium acts as a replacement for the water and you can mix it up with the paint – it works particularly well with watercolour in tubes. The effect is gnarly and unpredictable, but it can present a nice uncertainty in your work, particularly if you're pairing the effect with very tight linework. Here, the grungy granular technique has a more pronounced effect on the lighter version below. These examples would work particularly well as an expressive sky or backdrop to a people study.

Taping off borders

I'm a 'ragged edge on a painting' kind of guy, but on some occasions, the finished sharp edge on a watercolour can turn my head. Some watercolourists swear by this technique and have their paper already pre-taped before heading out. It's a strong watercolour game, and I have to admire them for it and there is a certain charm to the contrast between super-clean edges and soft blooms of watercolour, a kind of yin-and-yang approach. This technique can work just as well in a book as a loose sheet of paper. At some point in your watercolour journey, give it a go and I guarantee you will at the very least enjoy the final moment when you peel off the tape (there are entire YouTube channels devoted to this act).

Sponging

Small, natural sponges are widely available in all good art stores and make a fun addition to your watercolour kit. I use these primarily to help render skies and trees, but they can come in useful across the board to add texture to your watercolour. Try dabbing a dry sponge onto wet watercolour for an interesting feel that works very well for foliage or clouds. Dab the damp colour using the sponge onto the white paper for a subtle, graduated effect. It's a neat, easy trick that adds an ethereal element to your watercolours.

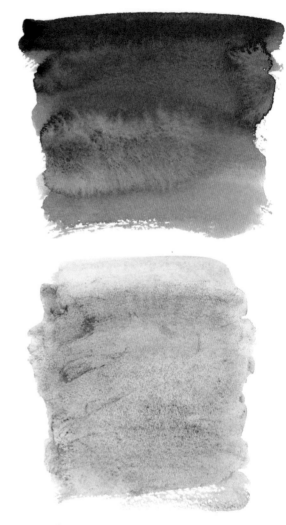

Granulation

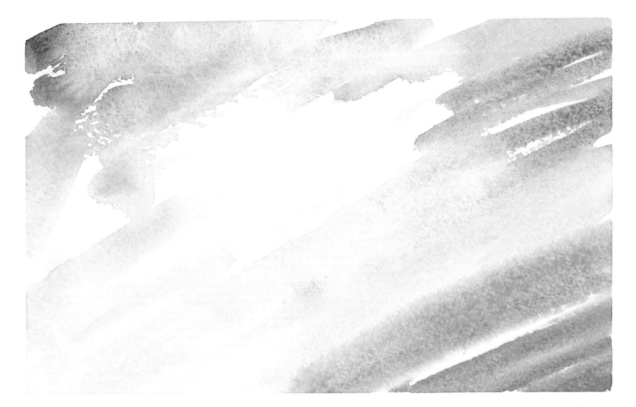

Taping off borders

Sponging

Skies

To sky or not to sky? Watercolour has a long and rich tradition of wonderful skies, and as a medium it undeniably has the ability to capture epic skies. But I try not to fixate on the sky in my works, and I avoid the temptation to always add something to the top half of the painting.

In urban watercolours, I'm less interested in the blue (or grey if you live in London as I do) of the sky in my paintings, but I do recognize that we need to have a few strategies up our sleeve to make the sky work in our watercolours without making it a big deal. Alternatively, sometimes the sky is all you need to add to your sketch in watercolour, and you can leave the rest.

The examples I've chosen here range from the bold and edgy, to the soft and supportive. Try splashing the pale blue, grey and yellow around in the first instance and then play around with the wet-on-wet technique (see page 53).

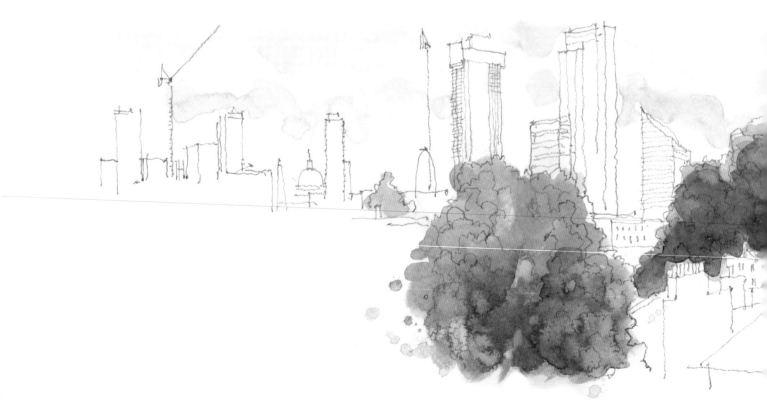

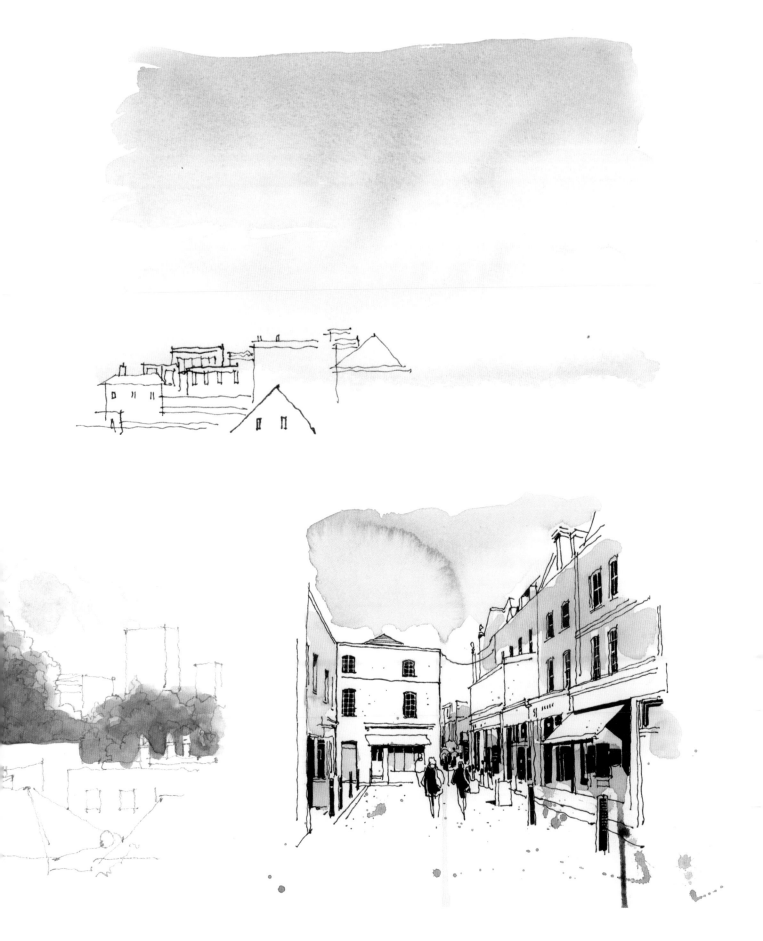

Scumbling

Scumbling is an age-old artistic technique that involves putting another layer of paint on top of a dried layer of watercolour in a textured fashion to create a deeper, textured approach. You're probably already scumbling without realizing it! The key part of the technique is to ensure that the base layer of watercolour is completely dry so that the textural strokes that you apply don't fuzz and bleed into the base layer. Keep your scumbling strokes random and 'scribbly' and you'll find that the wet, pale paint creates its own texture on top as it dries. The scumble element in this watercolour drawing are the rooftops and the variation in the colour of the tiles, which was applied after the base layer had dried. Very satisfying!

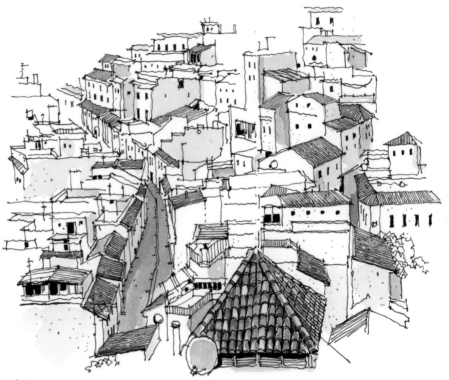

Scumbling

Pushing colours

Sometimes, it's great to cut loose and really let your hair down with watercolour. Realism isn't always the ultimate goal and bringing some crazy colours into the mix gives a sense of freedom and experimentation. Next time you have a scene that looks a little dour from a colour perspective but interesting compositionally, ignore the natural colour palette and have a bit of fun with it. While you're at it, don't worry too much about perspective and the other 'responsible' stuff! Begin by pushing your entire palette to the bright side of the spectrum and see what happens – this kind of exercise is good in the depths of winter when the colours aren't quite popping and you need a bit of brightness.

Coloured background

Painting directly onto a coloured background, whether it be paper or a wash that you have laid down, is a technique that takes some getting used to. The translucent nature of the watercolour paint is affected by the background colour, but it can deliver an interesting effect. Make a virtue of the colour's interaction with the paint to create something unusual, and buck the trend of watercolour paintings that tend towards a white background. Add white gouache or gel pen on top to really make the highlights pop.

- -

TIP

Put too much colour on or made a mistake? While you can't totally eradicate your mistake, it is possible to lift off colour using a dry brush or paper towel immediately after you put the paint on the paper. Don't wait until it is completely dry or it will be unfixable. You can use a clean, wet brush to 'scrub' on drier areas with water and bring the colours off the paper. If the area is still semi-wet, you can use a sponge or paper towel to lighten the paint you've applied. It's not foolproof, but it's always useful to have up your sleeve.

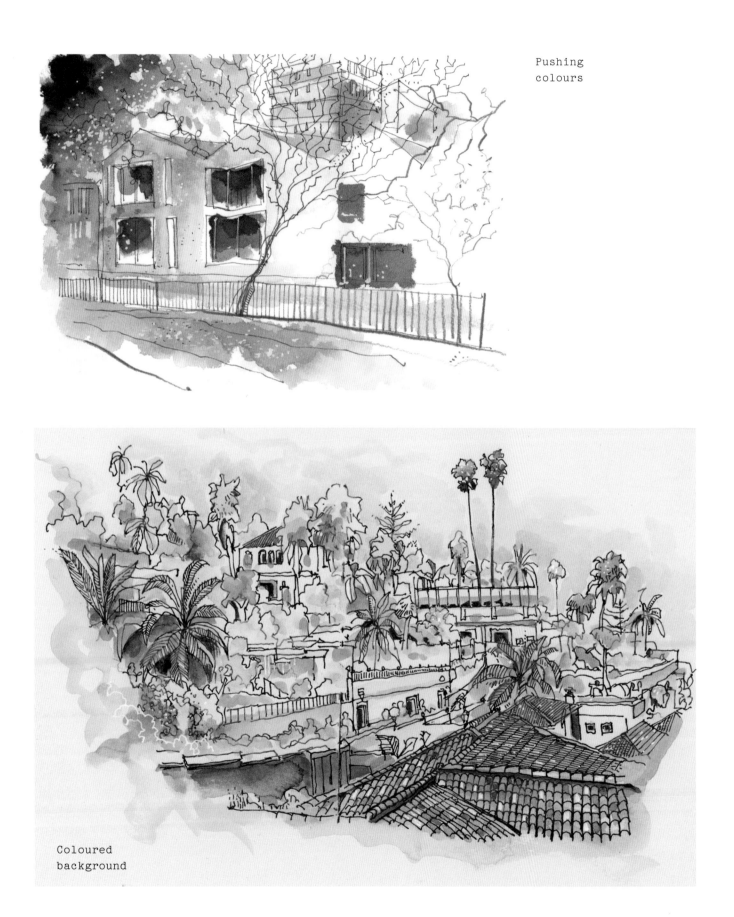

Pushing
colours

Coloured
background

Scumble away
Exercise 1

In this exercise, we're going to take a look at how the scumbling technique can add depth, texture and interest to your watercolours. Don't be put off by the mysterious name, it's really a very simple technique and I'm convinced that, once you have a feel for how it works, it is one you will use time and time again.

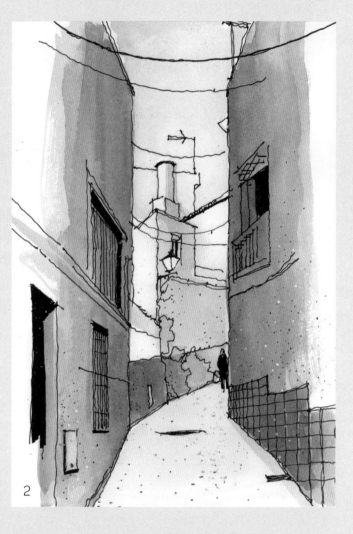

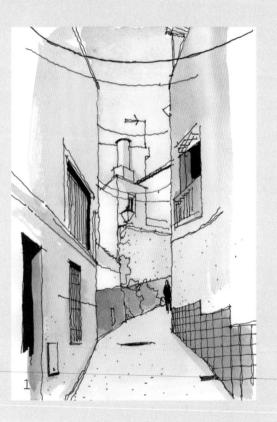

1. Add your first layer of watercolour, as you have been learning in the previous exercises. In my example, I've added the watercolour in a moderately flat style, using some texture to represent the rustic style of the Mediterranean walls. Start pale as we're going to build the layers of colour. Use the limited colour palette technique, remembering to use blue mixed with black for the shadows.

2. Use the scumbling technique to add further layers of texture. When the base layer of watercolour is completely dry, mix up a slightly darker version of one of your key colours with plenty of water so you can mix on the page as you go. I have started with the wall colour, which I have created with a dark blue/grey. Load your brush (I'm using a 4 round brush) and scribble or gently stipple the wet paint on top of the dry, being conscious that the mark you are making will be lighter when it dries. Nonetheless, if you feel that your brush strokes are too dark, dab them off with a dry brush or paper towel. Let dry, and assess the texture.

3

3. Keep building the layers as you go. As a rule, try to build darker from the bottom to light at the top. Mix up the weights of the colour and the amount of water, experiment and have fun – you can go as dark as you like in the foreground. This technique is tailor-made for roughly rendered walls as it portrays the textured effect perfectly.

4. Build the scumble out across the ground and be careful not to make the textures further away too dark – the further the distance, the lighter the line and the colour. I'm having to resist the temptation to go scumble-mad in my example, as I think the texture works great in the immediate left-hand corner and upwards. I have very quickly added another dimension to my work with a few simple brushstrokes. This technique works incredibly well across buildings, greenery (especially trees) and busy street scenes with dappled shadows.

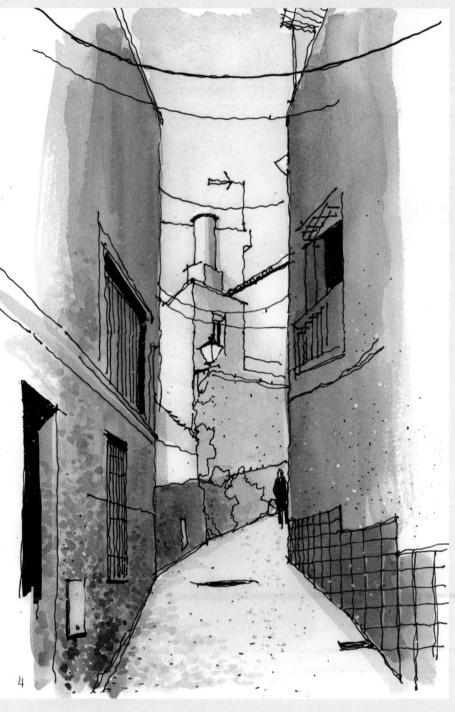

4

Anything but flat
Exercise 2

I believe that the secret to success in watercolour is being able to master the flat wash. There is nothing more satisfying than being able to lay down some delicately even colours to build on top of, or even just leave as they are. In this exercise, I want you to practise laying down the base colours and building them up gradually. This is great practice in mixing colour, adding enough water to make the paint translucent, and applying in minimal strokes to keep the paint consistent in application.

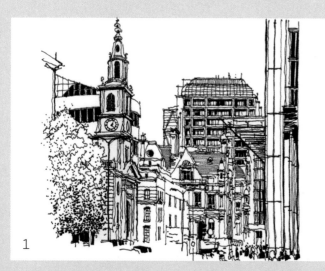

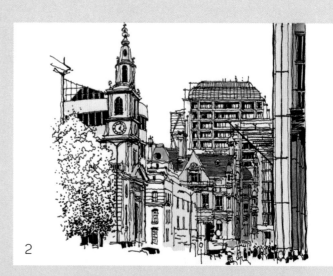

1. I have selected this lively scene and plan to use watercolour to help delineate the drawing and differentiate the various subjects from each other. It's easy to get lost with a drawing like this and lose sight of the relationships between the various elements. This is where watercolour comes in. I want the water to be loose but flat, so no 'tight' edges – I'm not too worried about accuracy, but I am mindful that I don't want lots of colours fading into each other. I'm starting with the church as it sets the tone for the scene – I'm going in with a 4 round brush with super-translucent cream to represent the stonework.

2. Mix up enough of each colour so you can lay enough down to get the flatness we're looking for. If you only mix a few drops, you'll find your brush gets too dry and when you mix some more in your palette, the colour may be darker or lighter. Start to add colour to buildings in the foreground and distance, remembering our rule of colour and line weight getting lighter the further away they are. I'm also adding some darker shade to the dried church base colour to represent the shadows (technically, this counts as scumbling, see page 82).

3. Add the rest of the colours judiciously as you go and try to make sure that the colours of buildings next to each other are differentiated enough. This will help with the clarity and 'reading' of the painting. I'm building the tone and trying to keep the effect smooth and even. As you add your colour, keep your brush loaded with diluted watercolour, bearing in mind you can always build up. I have left white pops of paper in and among the buildings – try not to fill every nook and cranny with paint. White space will help the scene breathe and accentuate the colour. Keep your brush strokes confident and fluid – this will help lay flat colours.

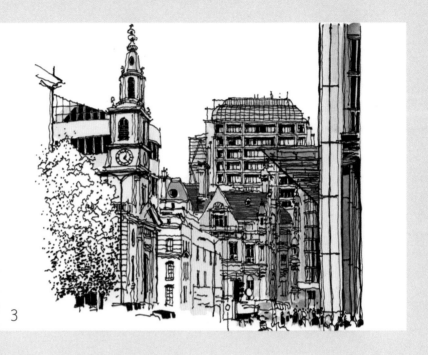

3

4. Build the depth of colour that the scene is asking for. I've ended up going quite dark with some of the shadows as it was a sunny day, and the shadows help with the definition of the buildings. When you have a busy jumble of architecture like this, it helps to have flat colour and layers on top of it. I put the sky in as one of the last of the watercolour additions, and I really think it helps to lift the work, especially with the white of the page representing the clouds. I did get a little 'movement' in the sky in terms of watercolour bloom, which I think contrasts nicely with the crisp architecture application. Finally, I added some white gouache to help lighten the dark grey-and-black foreground and selected windows.

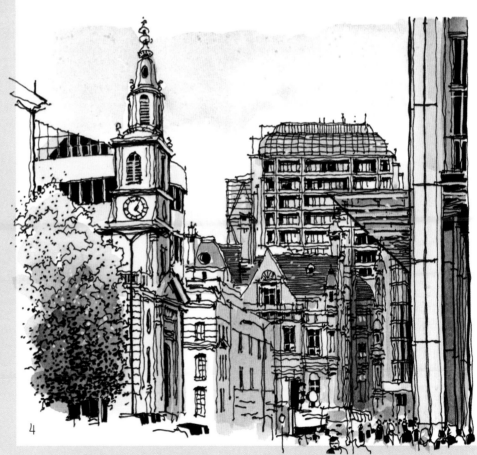

4

Playing with creative license

Although my preferred drawing and watercolour style is along
the more accurate, journalistic lines, there is always scope
to try new things and challenge yourself. I wanted to include
some thoughts here on cutting loose a little bit and freeing
ourselves up to experiment. I find it hard to break free
sometimes, and that's why I am often keen to try a new or
unexpected medium for my drawings before I add watercolour,
just to see what happens. Nine times out if ten it's a success
and you've discovered something new about your practice.

- -

So, if you draw in pencil, try pen. If you draw in pen, try
crayon or coloured pencil. Can't fit everything onto your
page? No problem, go for a montage – who's going to
know? Watercolour doesn't have to be this delicately,
carefully observed medium – ultimately, you have the
creative freedom to do what you like. Give yourself
permission to try something different, and go for it!

White gouache and black ink on textured coloured paper stock.

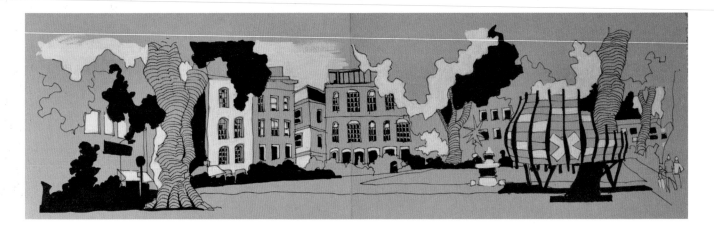

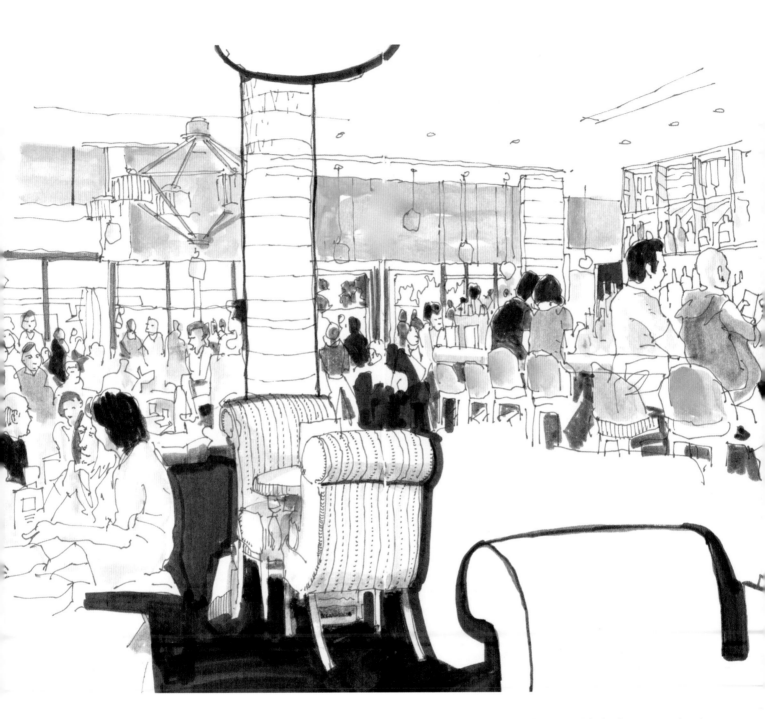

In these images, I have tried to accentuate the drawing style to allow freedom to make things 'un-accurate', creating a fun and distinctive interpretation of the scene.

Watercolour and black Indian ink on tinted paper stock.

Cut loose
Exercise 3

My normal approach is to be quite naturalistic when drawing, so this exercise is a reminder to be relaxed and have some fun with techniques and execution. There are lots of ways to cut loose and experiment, so here are just a few thoughts that fit with my general approach. You will doubtless find your own artistic release valve along the way.

1

1. This is a busy street scene in the old town of Jaffa in Israel, so I want to reflect the vibrancy and life of the situation. Let's see how we can mix things up by using a few new combinations. Firstly, I'm not using pen, which is a big departure for me. Instead, I'm starting off by using normal coloured pencil to draw the lines of the buildings in the colour they appear in – this is a good trick to create instant harmony when you add colour. Don't worry too much about the structure of the buildings – just block the shapes at this stage.

2. I block in the sky with watercolour to give a sense of the buildings that touch it, without drawing the buildings. This technique doesn't require too much accuracy and helps to shape the sky. I've used a large brush (10 round) with a nice point to get the sharp edges of the rooftops.

3. I start adding shadows using a dark blue-grey, mixing up a dark blue and black (remember the blue shadow rule) and letting the rhythm of the shadows dictate the shape of the painting on the left.

2

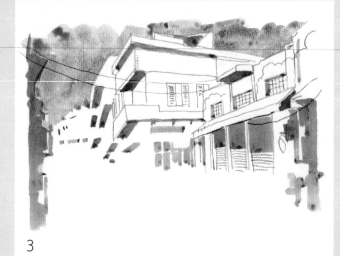

3

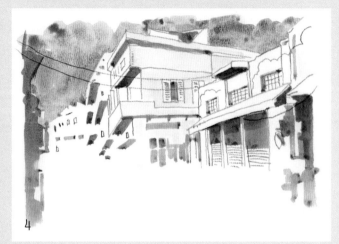

4. Take a step back to look at the scene and think about the colour. I could almost leave this as is – the unfinished version is so attractive to me and if you feel that way too, down tools. On this occasion, I'm going to push on for the purpose of the exercise to see what else we can do. Adding some warmth to the building on the right brings something new and fresh, so I decide to build on this, staying loose. I add some more pencil lines to add detail and some darker tones (by scumbling) to the shadows.

5. The final stage is adding people to the foreground and my approach here is very much along the lines of our exercise in Chapter 2 (see page 46). Be free and easy with people shapes as they are setting the scene and not the entire focus. I'm using a large brush with black watercolour paint here, but you use what you like – pencil, pen or charcoal will all work. Experiment with darker shades in the foreground and paler shades as they fade into the background. Remember, you are trying to convey atmosphere and not accurately render a scene. Use your creative license to deliver a scene that is impossible with a mere photograph.

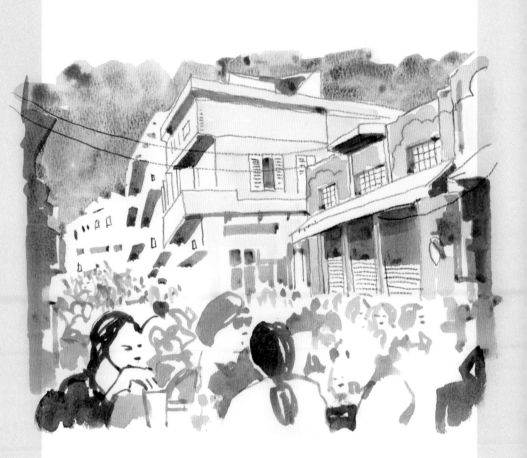

It's all about detail

A key question with watercolour is always going to be how much detail to include and how much to leave out. My style is naturally quite detailed so I can sometimes find it quite a challenge to cut back on it. My instinct is always to add more, and not edit the scene in front of me. But watercolour as a medium can be quite forgiving where detail is concerned — by its very nature, it encourages the artist to be expressive and not get too bogged down. I'm generalizing massively, of course, as you can still go to town on the minutiae of your subject matter, but I suppose what I'm saying is, you don't *have* to.

--

The following couple of exercises explore techniques that will encourage you to not get hung up on the detail, leave things out, be selective on watercolour application and think about your subject matter in a creative way.

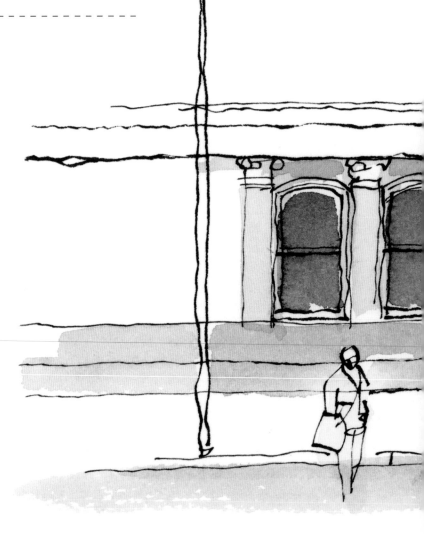

This painting is a good example of
selectively ignoring parts of the
scene that you are painting to
create an effect. I'm zooming in
on the buildings in the centre,
and leaving out the detailing of
the roof tile, creating a
geometric feel.

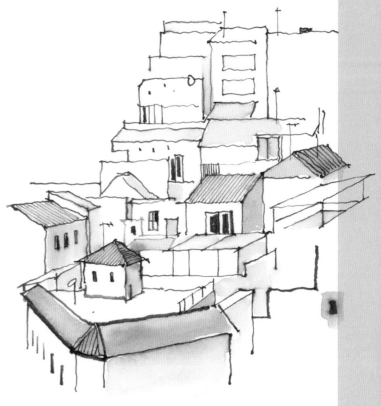

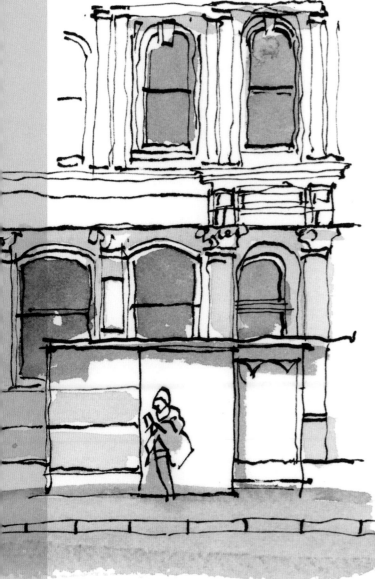

I'm more interested in
creating a fast watercolour
snapshot here, so I'm not
worrying about detail. I'm
just looking to capture the
basic architectural shapes.

Leave it out
Exercise 4

This exercise starts with a simple line drawing and finishes with a more interesting and enticing finished illustration by selectively adding watercolour. Start with an existing line drawing that you have already drawn or a photographic reference of a location that you've not been to before.

1

1. I'm using a waterproof 0.3mm fineliner for the linework in this exercise. I'm looking for a crisp, decisive line, but you could use a soft pencil if that's what you prefer. Start in the middle of the scene where the eye is drawn to and then work out from the centre. I'm trying to keep both the line detail and the colour minimal, so try to keep the shapes simple and unfussy.

2. As I build out the drawing from the central starting point, I'm already thinking about what to leave out and what stays in. Thinking about composition is important when omitting subject matter. Ask yourself if leaving certain elements in aids or hinders the composition, and if it makes the overall shape more interesting. I'm going for an asymmetrical feel with trailing lines drawing the eye into the centre.

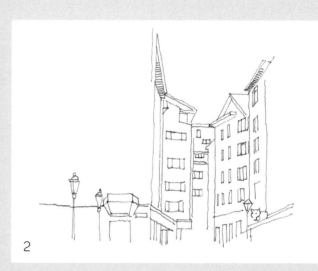

2

3. I'd already decided to concentrate the colour in the centre of the composition because the colour is essentially the detail here, and it is going to do most of the work in bringing the scene to life. Start by adding minimal colour in a controlled fashion to match the lines – the renders of the buildings and architectural shapes are an obvious place to start. Build out from there, testing your colours on scrap paper to test their strength.

3

4. Add some other building colours, keeping them in the same tonal value, which in my case is on the warm end of the spectrum. Darken the shadows using black and a touch of blue as we have learned before. Don't fill every bit of white space – leave selected unpainted areas to give it a light and airy feel. I'm looking for a contemporary graphic feel rather than realism.

4

5

5. I decided to add a fresh blue sky, which really helps bring the scene together by contrasting the warm colours. The white space of the clouds between the sky and the buildings provides a welcome breather and helps the colours pop. At the last minute, I also added some bustling crowds in the foreground using a light grey brush marker. It brings a vibrancy and energy to the scene and because we're not worrying about detail, we can put these people in very quickly. It's fun to experiment with people in your watercolours and as you become more experienced and your confidence increases, you will find adding people a useful technique to bring immediate life to your artwork.

Just watercolour

While we are investigating the use of detail in our watercolours, I wanted to explore further the idea of only using watercolour paint and nothing else in this chapter's final exercise. We touched on this earlier in the book in a warm-up exercise, and I wanted to explore what happens when we put down our pens and pencils and just paint what we see. This exercise may at first seem technically very challenging, but I think it is worth putting aside your fears and giving this worthwhile project a go.

- -

In many ways, having a pen or pencil line drawing to follow makes life easier from a watercolour perspective – you've worked out your proportions, you've measured to get a faithful representation of the scene and you have a guide to follow. So why paint without that safety net? It's a good question and one that participants often ask me in workshops. The answer is predominantly to push yourself because when you learn advanced techniques like these, they improve your watercolour skills tenfold. This technique may not become your regular 'style', but you will see how looking carefully at the shadows and shapes without linework teaches you to look more carefully at what you are painting rather than relying solely on your pre-drawn linework.

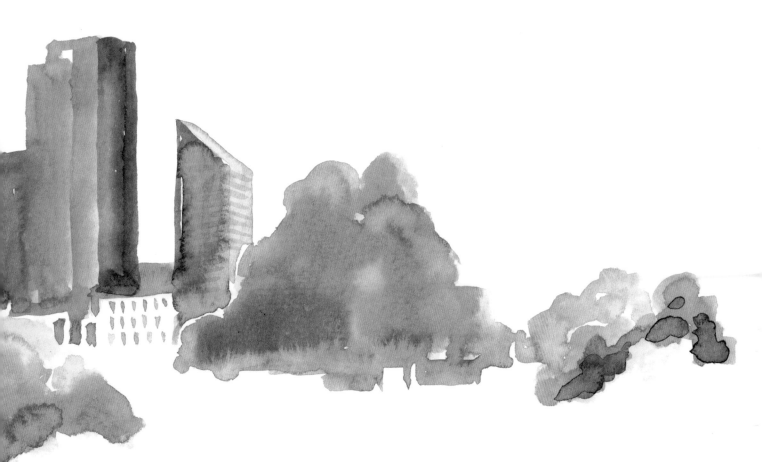

No lines
Exercise 5

In this exercise, I want you to think of your paintbrush as a pen or pencil.
You are going to be using your brush to articulate the subject matter on
the page, without the aid of any other medium. Think of it as a liberating
experience and don't worry about accuracy or making mistakes. I also
encourage you to think of the white paper (or whatever colour paper you
are using) as another colour in your palette. We are also going to utilize the
paint-layering techniques that we learned in Chapter 3, as carefully
building the colour is key to a paint-only approach.

1

1. Begin by selecting a fairly simple scene where there are
only a handful of key components, and decide what the
focal point will be. I chose this view because I liked how the
supporting foliage and foreground building framed the view
of the church. Having good light is helpful as the shadows
are the defining factor for us to see and understand the
structure of the building. As always, start pale and build up.
Think of this first layer as the background colour of the
building and you are then adding shadows. Don't forget to
leave whites for highlights.

2

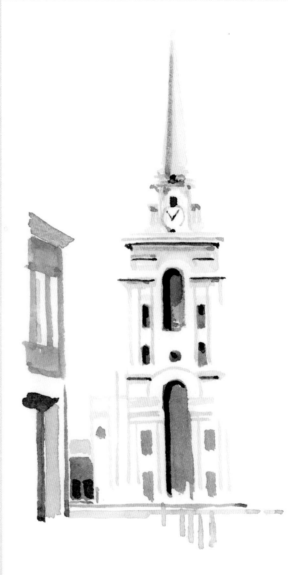

3

2. Build the shadows in the architecture and add some darker greys and black so you can get a feel for how dark you need to go on the building. Drawing with a brush without pen or pencil is tricky at first, but if you make sure to use a brush with a point (I'm using a 3 round), you will see how it will settle into a pen-like shape, so that you are essentially drawing with watercolour.

3. I'm now building the paint up, and getting bolder with the colour as the artwork progresses. The foreground building gives us a new pop of colour and helps me work out how much depth we need on the church. Remember, we want to stay minimal and leave as much detail out as we dare. I want the viewer to do the work when they look at the finished watercolour, adding the detail in their mind's eye.

4

4. Next is the tree and I want to keep it as an abstract shape as opposed to detailed foliage. I'm trying to keep all the paint finishes similar across all subject matter in this scene, to help the painting hang together.

5

5. I use the sky to give even more definition to the church shape, leaving a small amount of white around it. Without the blue of the sky, the church shape is too subtle at first glance.

6. I should probably have left the watercolour at the end of Step 5 as it has done everything we wanted it to do. But I couldn't resist going in afterwards and adding some final touches. I'm not cheating as I'm not adding linework as such, but I used some watercolour brush pens to beef up the blacks and add some subtle architectural detailing. These additions are very much in the spirit of what we are trying to achieve, conveying detail without actually putting detail in.

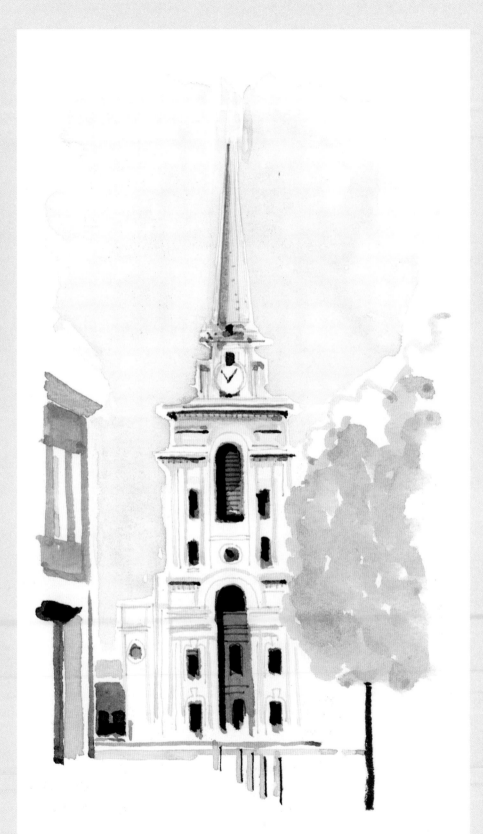

6

Finishing an artwork

In this chapter, we tackle the thorny issue of knowing when your work is finished, and when to put down your pen or brush.

Getting near the finish line with a watercolour can be one of the trickiest parts of the process — is there enough detail, or does more need adding? Are the colours deep enough or do I need to add more later? Should I fill the white spaces with colour or do they add breathing room?

The point at which your watercolour is finished is a decision that is solely in your hands. It's about having confidence to know when to stop. Of course, there's no one-size-fits-all approach; sometimes, brevity is key with certain subject matter and other times, it's all about layers and detail.

In this chapter, we'll be looking in more detail at troubleshooting your artwork, and helping you to assess when a work might be finished. In the final section, we will go beyond the finished artwork and look at the opportunities available to you for sharing your work with a global community of artists and art lovers.

How to finish

In this section, I've tried to cover the FAQs that artists of all levels ask me when they are nearing the end of their sketch or watercolour. There is never a 'silver bullet' answer to every question, because art is subjective and we all have our own approach and aesthetic, but where possible I have tried to give various options or views on each topic.

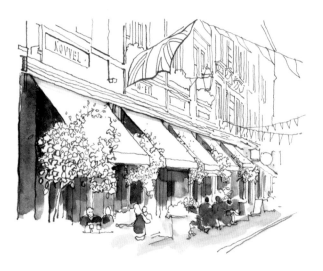

When to stop?

This is by far the most frequently asked question. On the whole, my advice is always that less is more. Unfinished areas of a sketch can be just as powerful as the areas filled with drawing. The mind fills the gaps that the eye sees, and the space intrinsically becomes part of the sketch. This isn't to say that a page should never be completely filled because there can be a joy in that, as long as the subject matter benefits from it.

Knowing when you are happy with your work is all about feel and experience. The more you draw and paint, the better you will become at trusting your gut and knowing when to stop. See how artists you admire approach this vital stage in the creative process, and take tips from them. Try something new and uncomfortable and see how that feels. For instance, if you have a tendency to overwork and go too far, set a time limit and be disciplined about stopping when you feel the artwork needs a lot more work and you would normally carry on. It can be very liberating.

In this painting, I'd be quite happy to call time and leave the subtle blue-grey shadow and linework to carry the subject matter. I love the minimalism...

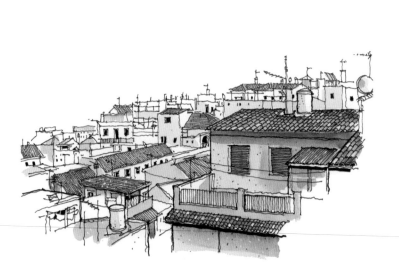

I started by just focusing on the rooftops and shadows with the paint, and I really like the sea of white paper the watercolour sits in. Job done...

...However, I decided to go all the way with colour to see where the painting would go. Here, adding the rest of the watercolour delivered a more rounded and realistic finish, so in this instance, it was worth pushing it further.

- - - - - - - - - - - - -

...But a few days later I came back to it and wondered if the addition of a crisp blue sky would transform it. What do you think?

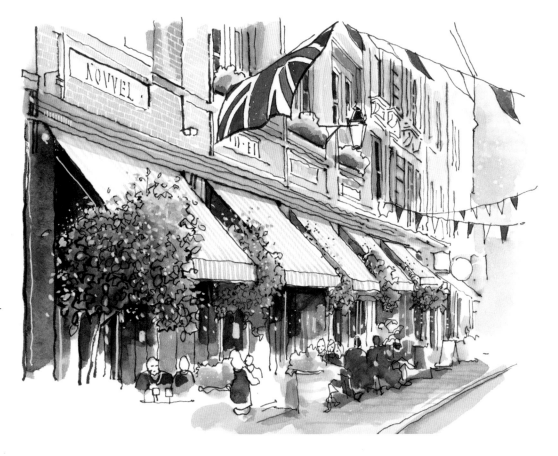

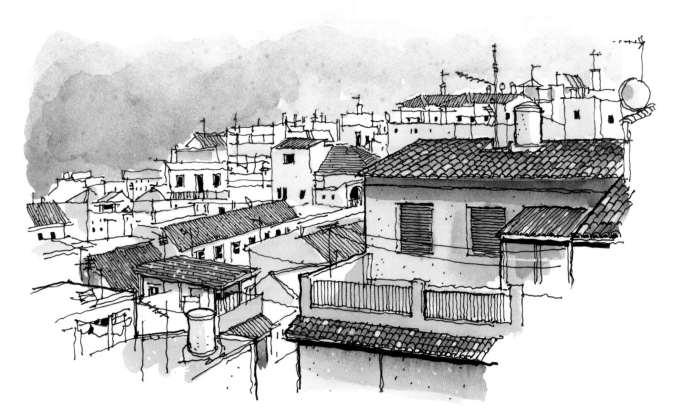

The shape of it

We have already touched on composition in Chapter 1, but it's important to think about it constantly, especially when you are getting close to the completion of an artwork. Always try to keep the following questions in mind:

- How is the drawing looking? Does the placement on the page add something to the overall mood and attitude? If it doesn't, what can I add to enhance the composition?

- Is there enough or too much negative space? Which gaps can I leave unfilled? Be brave and remember that white space is a wonderful thing.

- Do I need to add more elements to make it believable or recognizable? Be careful adding superfluous elements that overcomplicate the scene. You can always add extra details later if you think you're missing something.

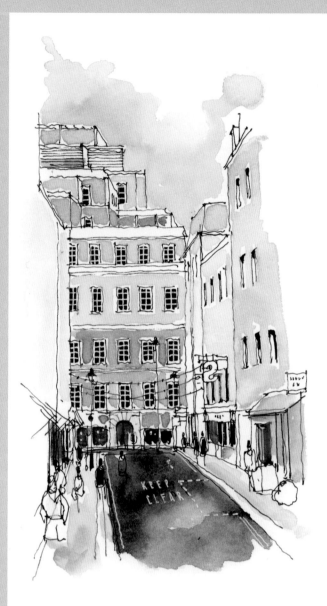

At the outset, I decided the shape of this scene was going to be a tall portrait format, stacked on the left-hand side of the page with white on the right-hand side. I resisted the temptation to add any more buildings on the right.

The key feature of this painting is the sky and the green hill in the distance, so I started adding colour there. I cautiously added rooftop greys for the slates and a touch of foreground warmth, and put my brush away.

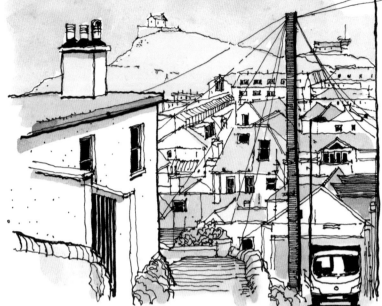

Just two colours here: blue and black with various washes of each. It's fun to stay within a very limited palette so try keeping it tight.

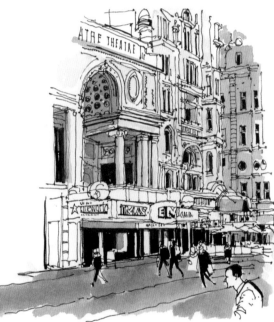

This is a dynamic street scene, and the lines feel immediate and sketchy. I wanted to keep that mood with the colour so I kept it minimal and used the solid black ink to create weight at the base of the painting.

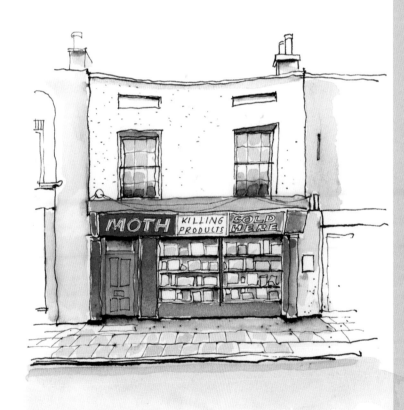

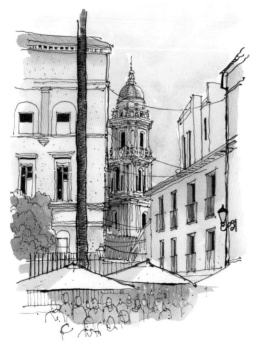

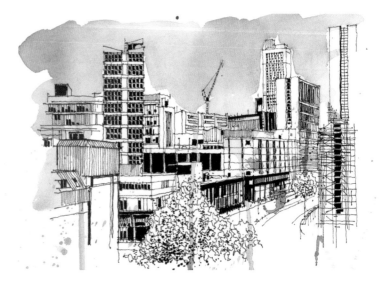

The added detail of the people in the foreground gives life and context to the scene.

No colour detail on the buildings whatsoever is bold and edgy. Just the loose sky wash and nothing else.

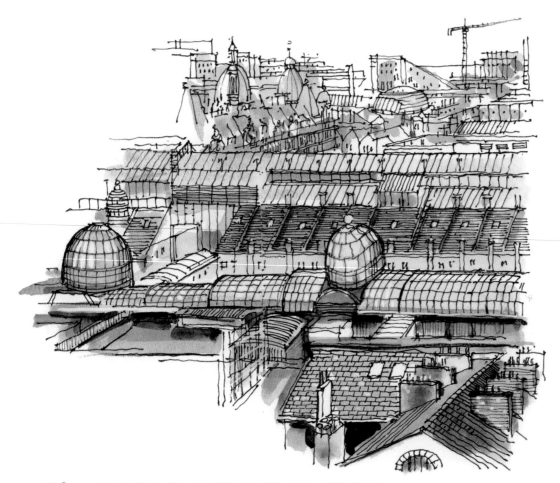

I went to town on the detail of these rooftops as I had the time. Without the detail, it lacked authenticity and scale.

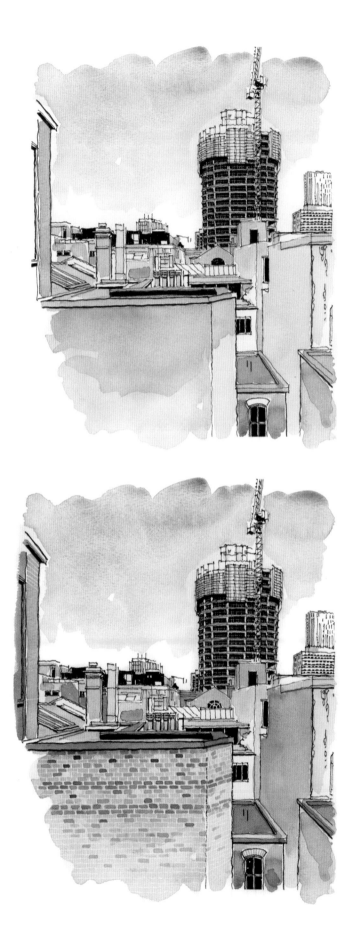

It's all in the detail

It's often said that the devil is in the detail, and this is especially true with watercolours. My inclination is always to capture as much of the detail and textural depth of an urban scene as I can in a controlled fashion. Richness of detail helps tell the story of the scene that I'm painting. But other watercolour artists use less obvious detail and still manage to beautifully convey the subject matter they are painting.

When it comes to looking at the level of detail in your work, begin by carefully considering the linework (if you are using line). Is there enough detail to bring the scene to life? Is it too simplistic and spare? Would it benefit from a variation in weight or subtle detail adding in a finer line?

Be careful not to add extra information that is not required as this can sometimes detract from the spontaneity of the drawing and watercolour. Do you need to put all of that tree in? Does that building really need the roof slate detailing? If the answer is no, exercise restraint.

However, don't shy away from adding textural detail if you think it could benefit from it. If you are adding detail such as brickwork, really commit to it. I believe that as far as brickwork is concerned, it is all or nothing. No bricks is fine and all of the bricks is fine too, but nothing in between. If you're going all in on the detail, I want to see the construction of the building and the architectural details, and remember, they all have widths and depths so show them.

This scene has detail in the distance and less so in the foreground. The addition of the brick detailing draws the eye in to the tower in the distance, making the subject matter believable.

Depth of colour

The application of colour is another key area to think about when assessing if your artwork is finished or not. The great thing about watercolour is you can come back as many times as you like and add depth to the colour. We have explored the ways in which you can build up colour in wet-on-wet and wet-on-dry techniques. I often find that I'm initially very happy with the colours, but when it's dry and I come back to it, invariably I want to add more depth after the live drawing stage. My advice to anyone working with watercolour is to be open to that.

Sometimes, minimal linework and wash aren't quite enough to hold the viewer's attention. Perhaps the scene needs more colour and deeper shades. If so, build up the layers, but go carefully and work wet on dry to get a more accurate feel for the tones.

Where colour is an integral part of the scene, as in the examples shown here, take time to get the colour as close as possible to the subject matter. If the roof tiles of the building are a distinctive colour, getting the colour as close to reality as possible will give your painting authority and credibility.

Colour is a unique tool in helping to reinforce the sense of place of the subject that you are painting. In some works, the linework can act as a brilliant framework, but the watercolour is needed to deliver the clues to the visual information that the viewer needs to believe it. Take time to mix up your desired colours, ensuring your brush and palette are clean and uncontaminated with opposing colours.

I'm letting the black windows do all the work here with light and tight application of colour. When dry, I went back in and scumbled on top to add texture and depth to the colour.

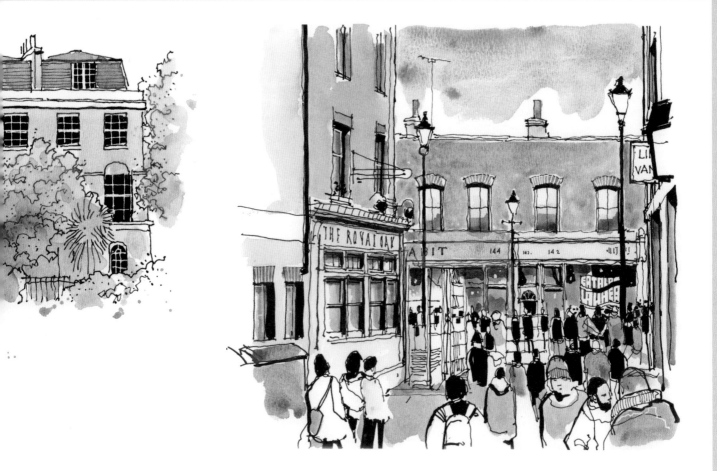

This was my first application of colour, loose and fairly strong. I wanted a minimal palette, too, so I used similar colours across the painting.

The bold and purposeful application of colour here captures the deep shadows of a sunny street scene.

Sharing your work

How to become part of the online art community

Social media is a powerful tool for every artist. If you do it properly, your work can be seen all over the world by more people than you would ever imagine. However, it's worth bearing in mind that keeping up social media accounts can be exhausting and is a job in itself. Some artists shun social media, and I can understand why as the downside of it has been well documented.

My own experience of social media has been a positive one, and I would definitely recommend dipping your toe in the water if you are a novice in this area. Instagram continues to be the best platform for urban artists to share their work and see what else is out there, although Twitter and Facebook are also options to explore once you are more experienced with sharing your work. Begin by following people and hashtags, and you will get a feel for the kind of content you enjoy and what inspires you.

Getting started with social media

Setting up your first social media account for your work is going to involve a lot of trial and error. I recommend setting up a dedicated Instagram account that is separate to any personal accounts you may have. Search the hashtags for artists doing things you like – watercolour, painting, ink, pencil drawing and so on – and give them a follow. When you're getting started, post your artistic content once a week. Don't be afraid to talk about your work in the post, how you did it, what inspired you, any challenges that you had to overcome etc. Interact, comment and like content that you enjoy, and you will soon find that people will react in kind. Hopefully, you will discover that having an active online presence with your work can lead to amazing opportunities to take your art journey to another level.

Top tips for sharing your content on Instagram

- Think about the shape of your artwork when creating it – does it need to be a little more square to fit neatly in the frame?
- Keep your content consistent in terms of look and feel, and don't post wildly different stylistic content.
- Carousels (multi-image posts) perform very well and the algorithms tend to like them.
- Video content often performs well so try shooting 'work in progress' videos of you sketching if you want to get your work noticed.
- Post at least once a week to build up your visibility.
- Follow other artists whose work you like and comment on their posts – this will help you get interaction and increase your followers and 'likes'.
- Share Instagram posts in your feed and use Stories too, as both will help boost your presence.
- Tag artists that you like, and they may well like and share your work.
- Always use hashtags on your posts – at least ten separate hashtags is a good figure to aim for.
- Try to reply to all comments on your posts and comment on other people's posts that you follow. It's great to get conversations going and really utilize the social aspect of the sites. Plus, it will boost your ranking in the algorithm and get your work seen by more people.

Urban sketching groups

For me, drawing and painting is a solitary exercise. I love the precious 'me time' where I can focus on one thing and the secondary benefits of mindfulness all come in to play. That isn't to say that it can't be done in groups, because it can, and I have run workshops where that is absolutely the case. Many artists enjoy a mix of both, in fact.

There are urban sketching groups that meet regularly to sketch on location all around the world and many are· affiliated to the global urban sketchers community (USK, www.urbansketchers.org), who regularly run workshops, events, symposia, sketch walks and more. Having attended a couple of USK events, I would say they are ideal for the novice and intermediate artist. You will be in a group of like-minded enthusiasts who are all on the same journey and eager to learn how to get better. There are artists of all abilities and the atmosphere is welcoming and enthusiastic.

Urban sketching has seen a huge growth as a pastime in recent years and as a consequence, many towns and cities have urban sketching groups of all shapes and sizes. Search for groups in your area to see how you can get involved.

Acknowledgements

Dedicated with love to my wife Julie for her endless support, and our wonderful children Josh and Georgia.

I would like to express my enormous gratitude to the publishing team at Octopus, particularly Ellie without whose continued belief in my work and encouragement this book would not have been published. I'm grateful also to Ben, Rachel and Serena for bringing it all together beautifully and making the content sing.

Special thanks to the wonderful artists who have inspired me on my watercolour journey, in particular Lyndon Hayes, Simone Ridyard, Martyn Hayes, David Gentleman, Brian Ramsey, John Harrison, Glenn Hall, Lis Watkins, Jenny Adam, Boris Zatko, Stephanie Bower, Jeong Seung-Bin, Richard Hind, Ian Fennelly and Luke Adam Hawker.

Many more people were helpful along the way, and I am very grateful to them too. In particular, special thanks to Bryan Wilsher and Carl Hopkins for their enthusiasm and support.